Brush Pen Lettering

Grace Song

Ulysses Press

Published in the United States by:
Ulysses Press
P.O. Box 3440
Berkeley, CA 94703
www.ulyssespress.com

ISBN: 978-1-61243-683-8
Library of Congress Control Number 2016950668

Printed in the United States by Versa Press
10 9 8 7 6 5 4 3

Acquisitions: Bridget Thoreson
Managing editor: Claire Chun
Editor: Renee Rutledge
Proofreader: Lauren Harrison
Front cover design: Ashley Prine
Cover art: © Grace Song; background grid © binik/shutterstock.com
Interior design: what!design @ whatweb.com
Layout: Jake Flaherty

Distributed by Publishers Group West

Contents

Introduction

Lettering is the art of drawing letters using multiple strokes. Brush pen lettering is the art of drawing letters specifically using pens with a flexible brush tip. If you have always been interested in lettering but do not know where to start, then you're in the right place. This book serves as a comprehensive how-to guide for beginners.

Often people have the misconception that one must have good handwriting skills to also be good at lettering. This is certainly not the case. Although good handwriting may provide you with a good basis for learning lettering, it is certainly not a prerequisite. Lettering is not writing; it is the drawing of letters. So, with help building a strong foundation of basic strokes that are combined to make letterforms

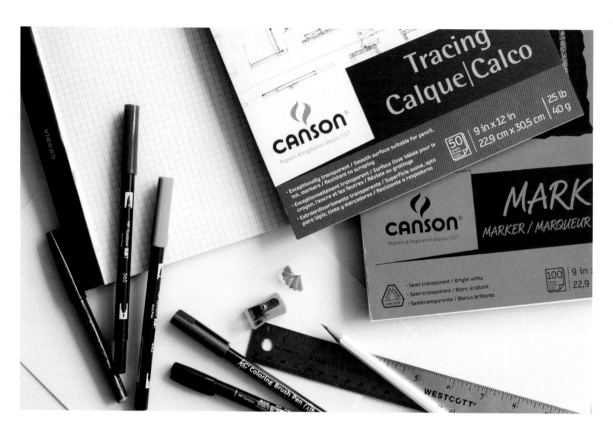

(letter shapes) and coupling that with study and consistent practice, you can definitely make your way into this fantastic world of lettering.

This how-to guide will help you get started with everything from choosing supplies to holding the pen to learning basic strokes that are foundational to your lettering journey. From there, you will learn how to combine these basic strokes to make letterforms, improve your consistency, and make progress. Next, the guide will show you simple ways to change the look of your letterforms, providing a basis for developing your own style. Finally, you can apply everything that you learn by delving into DIY projects that are both fun and approachable.

In a world gone digital, lettering provides the perfect hand-drawn, organic element to any design, whether it be snail mail, a custom quote for a loved one, or a company logo. The act of lettering also nurtures the creative facet of your soul and allows you to develop at your own pace. Lettering has provided so much joy in my life and my hope is that it can provide joy in yours, too.

Let's get started, shall we?

CHAPTER 1

Getting Started

Beginner Tools and Supplies

The great thing about brush pen calligraphy is that you only need a few tools and supplies to get started. By using the right tools and supplies at the beginning of and throughout your lettering journey, you will experience more success and less frustration along the way. As you gain experience, you can explore a wider variety of brush pens and other tools.

Brush Pens

When it comes to brush pens, there are three different types of tips: natural hair, synthetic hair, and felt. In general, the felt tip brush pens are best for beginners because their marker-like tips are firmer. You will have more control over firmer tips, and they will lead to more predictable results. Natural and synthetic hair tips are more flexible and require more practice to get used to. Regardless of the type of tip, all are flexible and respond to different pressures, thus creating varying stroke widths.

Though brush pens with felt tips are recommended for the beginner, there is no right or wrong brush pen to start learning with. It depends on personal preference, how heavy-handed you are, and how widely a brush pen is available. It is important to be aware that not all brush pens are created equal, so if you start off

X-height = 7.5 mm *small scale*

X-height = 15 mm *large scale*

with one, give it an honest try, and are still having a difficult time with it, try another. Don't be afraid to experiment and find the brush pen that is just right for you.

Let's take some time getting to know some large- and small-tipped brush pens with felt tips. The size of the tip generally determines the scale of lettering that can be produced. Thus, large-tipped brush pens are suitable for large-scale lettering and small-tipped brush pens are suitable for smaller scale lettering.

Regardless of tip size, all the brush pens described here are widely used and loved among hand letterers and are enjoyed by both beginners and those with more experience. This list is certainly not exhaustive but is a great starting point.

Large Tips

Tombow Dual Brush Pen: This pen is fitted with a brush tip on one end of a long body and a bullet tip on the other end. This large and flexible brush tip is used to create a variety of shapes and strokes with different widths. The bullet tip is stiff and can be used to form a monoline that only creates strokes of the same width. The brush tip will be the star in this guide. This is the brush pen that I started with and has continued to be a favorite.

Sakura Koi Coloring Brush Pen: This pen has a brush tip that, while flexible, is slightly stiffer than the tip of the Tombow Dual Brush Pen. The body of the pen is shorter in comparison and perhaps easier to hold.

Sakura Pigma Brush Pen: This pen has a brush tip that is firmer than its Koi Coloring cousin. It is only available in black and comes in three sizes: FB (fine), which is best for small-scale lettering; MB (medium); and BB (bold).

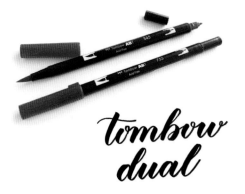

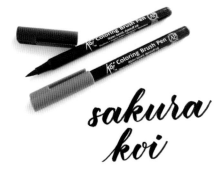

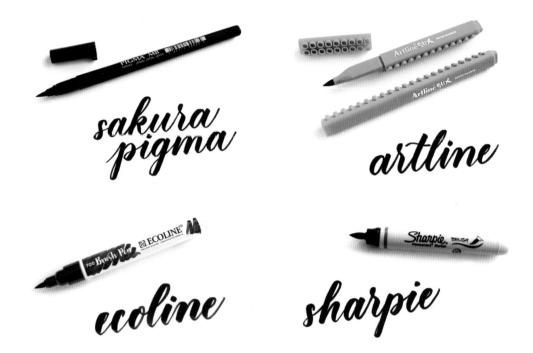

Artline Stix brush pen: This pen is like the Sakura Pigma Brush Pen in terms of flexibility. It has a brush tip that is firmer than the Tombow Dual Brush Pen and its body is shorter as well.

Ecoline Brush Pen: The Ecoline Brush Pen feels like the Artline Stix brush pen. It is highly pigmented and writes beautifully, giving way to very thick downstrokes.

Sharpie brush pen: The Sharpie brush pen has a flexible yet firm tip that a heavy-handed person may be partial to. Many brush pens have water-based inks that can be blended together like watercolor paints (see Ombré Effect or Blending on pages 56–61) but the ink of the Sharpie brush pen is permanent. It also bleeds through to the other side of your paper; this may be bothersome, especially if you would like to use the other side of your paper for practice as well.

Small Tips

Tombow Fudenosuke Brush Pen: Compared to the Tombow Dual Brush Pen, the Fudenosuke comes in a hard tip (black barrel) and a soft tip (navy barrel). The body of the pen is small and easy to hold, and its brush tip is much smaller than that of its counterpart.

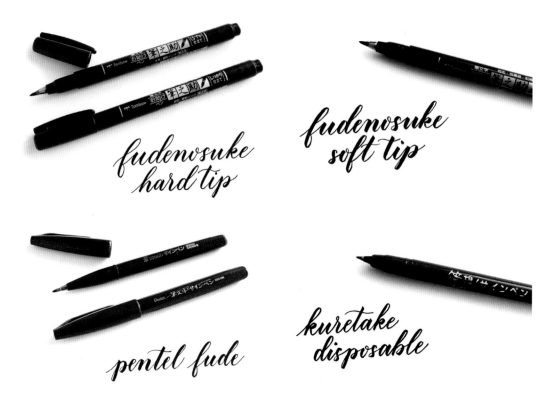

Tombow Fudenosuke Brush Pen, Twin Tip: This pen is just like the regular Tombow Fudenosuke Brush Pen in the hard tip version. The tip is firm, yet flexible, thus making it great for a beginner. It comes with two tips, one in black, the other in gray.

Pentel Fude Touch Sign Pen: This pen is like the Tombow Fudenosuke Brush Pen in that it is fitted with a small brush tip on a small body. It feels natural in the hand and is relatively easier to handle than larger brush pens, making it a great beginner brush pen. The feel of this brush pen as it glides across the paper is undeniably buttery.

Other small-tipped brush pens worth checking out are the Kuretake Disposable Pocket Brush Pen (pictured) and the Zebra Disposable Brush Pen (not pictured).

Paper

Having the right paper is crucial for lettering because brush pens are sensitive to the texture of a paper's surface. So, the smoother it is, the happier your brush pens will be. Although a brush pen will fray eventually through normal wear and tear, very smooth paper is highly recommended to minimize fraying and make the tips last longer. Tips that are well taken care of will give you smooth lines and curves. Even your everyday copy paper is too rough for your precious brush pens!

For practice, Rhodia is one of my favorite brands of paper, as it is for many other lettering artists and calligraphers. It is extremely smooth and thin enough that you could slide a guide sheet underneath and still see the lines. This paper comes as a pad and you have the choice of blank, lined, gridded, or dotted versions. The lined, gridded, or dotted versions provide guides to help you keep your letterforms consistent in size. I tend to use the dotted version the most because the dots provide just enough guidance without being distracting.

Other types of smooth paper that are easily accessible and relatively affordable are laser printer paper, marker paper, tracing paper, and Bristol paper. Out of these, tracing paper is the most translucent and can easily be used on top of guide sheets and letterform exemplars.

Other Supplies

The pencil, pencil sharpener, eraser, and ruler are other essential tools that you probably already have in your home. They will help you to sketch, format, and lay out longer phrases in a purposeful way when you are ready to do so.

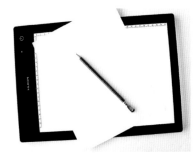

Finally, I recommend a light pad, which is a device with an illuminated surface. Next to brush pens and paper, a light pad is one of my favorite and most used tools for lettering. You can place a sheet with guidelines in between the light pad and the paper you are working on. With light shining from underneath, the guidelines

Light pads are useful when creating a final template for lettering.

will be visible through your paper and can help keep your letters proportioned and on a straight line. The light pad also comes in handy when you have drafted a layout of your lettering and you are ready to trace it for the final piece.

Brush Pen Anatomy and Ergonomics

Holding the brush pen at an angle, finding a comfortable grip, and strategically placing your paper in front of you are all factors you should consider while learning lettering. What works for one person may not work for another so, ultimately, you need to find what is best for you. But by understanding how a brush pen is built and being aware of how the angle

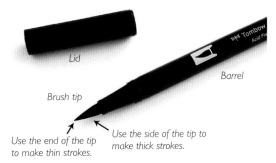

Lid

Barrel

Brush tip

Use the end of the tip to make thin strokes.

Use the side of the tip to make thick strokes.

of the brush pen, your grip, and paper position can change your outcome, you can have more success in the beginning stages of your learning.

How to Hold a Brush Pen

To take advantage of the versatility of a brush pen's tip, you should hold the brush pen at an angle (approximately 45°). When the tip is positioned at an angle relative to the paper you are lettering on, it will better respond to the different pressures you apply. With light pressure, the very tip of the brush pen can be used to create thin strokes. With heavy pressure, the side of the tip can be used to create thick strokes. If you hold the brush pen so that the barrel of the pen is perpendicular to the paper, then you will not be able to create a wide variety of strokes that are crucial to creating many types of lettering and calligraphy. In addition, the tips will fray much faster and cause feathering in your strokes.

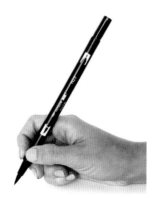 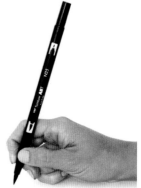

Holding the brush pen at an angle (approximately 45°) will allow you to easily apply differing pressures to create thin to thick strokes.

With this grip, the angle is too steep or upright. It will be difficult to create a greater variance of thicknesses in your strokes. You'll also fray your brush pens quickly!

How to Grip a Brush Pen

The grip used to hold the brush pen can vary and still produce beautiful thin to thick strokes. I happen to grip the brush pen in the same way that I grip a pencil or a ball point pen. It is not a grip that is traditional by any means; however, it still works because the brush pen lays at an angle. I also notice that while using the same grip for a brush pen as I would for a pencil or pen, my fingertips are positioned farther away from the tip. This changes the angle of the brush pen slightly, which means I can take advantage of the side of the tip and create wider strokes. Also, look out for where the body of the brush pen sits in your hand; the closer it is to the webbing between your thumb and index finger, the more angled your brush pen becomes. Push the barrel of the brush pen so that it sits in the webbing and see how that affects your ability to create a variety of strokes, particularly the thick ones.

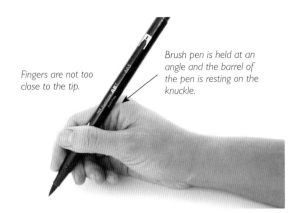

Fingers are not too close to the tip.

Brush pen is held at an angle and the barrel of the pen is resting on the knuckle.

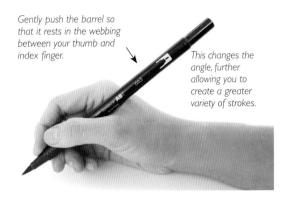

Gently push the barrel so that it rests in the webbing between your thumb and index finger.

This changes the angle, further allowing you to create a greater variety of strokes.

No matter how you grip the brush pen, always pay attention to the angle of the tip compared to the paper. As long as the tip lays at an angle, you are good to go. Much about lettering at the beginning of your journey is about experimenting with different pressures and getting to know your brush pen. Start with light pressure to create many thin strokes upward (a.k.a., upstrokes) and gradually increase the pressure to create increasingly wider strokes downward (a.k.a., downstrokes). How wide can you go?

Try experimenting with different grips and see if an alternate grip or positioning allows you to easily apply differing amounts of pressure for a greater variance in stroke width. Some letterers use this knowledge intentionally and change their grip to achieve a certain look in their lettering.

How to Position Your Body and Paper

When sitting down to letter, your body should sit square, facing forward. Place a piece of paper down at an angle in front of you and place your hand in a position ready to letter, with your wrist in a neutral position (not bent inward or outward). If your wrist is bent, rotate the paper (counterclockwise if you're right-handed, clockwise if you're left-handed) so that the wrist sits comfortably in a neutral position. Over time your wrist will thank you! Once you find the sweet spot, ensure that you now keep the grip on your brush pen constant at all times so that the angle of the brush pen relative to the paper stays the same. The angle of your paper may change, but the angle at which your brush pen is held relative to your paper should not change while you're lettering. As you letter across a page, your wrist and arm will do most of the work; the fingers will stay in place to hold the brush pen.

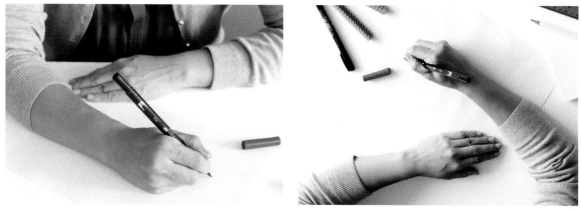

Correct body position: body square to the table and wrist in neutral position.

At times when you want to change the slant of your letters, you can rotate the paper as needed. When the paper is rotated to a greater angle, you will achieve a steeper slant in your lettering. When the paper is rotated to a smaller angle or more perpendicular to your body, you will have less of a slant in your lettering or even no slant at all. Regardless of the angle of your paper, the grip with which you hold the brush pen should remain constant, keeping the tip of the brush pen at a consistent angle relative to the paper (see Changing the Slant on page 62).

Wrist and Whole Arm Movement

When it comes to day-to-day handwriting, your fingers do most of the work, manipulating the writing tool to either print letters or write in cursive. You will shift your arm across the page as you need more space to write a message. When it comes to lettering, your fingers are static; the only thing they will be doing is holding the brush pen in place. Therefore, to move the brush pen in different directions, your wrist will bend and your forearm muscles will flex to do the work. This will make it easier to create smooth, flowing strokes. With large-tipped pens, you will create larger scale lettering. It is still possible to use mainly the wrist and forearm to create strokes in different directions across a page; however, when it comes to making even larger lettering and flourishing, using your whole arm will help you to achieve the desired stroke sizes and even smoother lines. Whole arm movement means that the wrist is relatively in line with the forearm and the movement comes from rotating at the shoulder.

For day-to-day handwriting, your brain goes on autopilot. You don't have to think about how to do it, you just do. For lettering, it may take a conscious effort to keep your fingers still for holding the brush pen and use the other parts of your arm, or whole arm, to make movements instead. Understanding and being aware of this now will save you time in the long run. It may be awkward at first, but with practice, you will develop more control and find a noticeable difference in terms of smoothness in your strokes.

Let's Get Technical

Applying Pressure

Brush pens are fitted with flexible nibs that respond to pressure. Different amounts of pressure are used to achieve a range of different stroke widths. By purposefully applying pressure, you can achieve the thin and thick strokes that are characteristic of beautiful hand lettering. When you create an upward stroke, you use light pressure; when you create a downward stroke, you use heavy pressure.

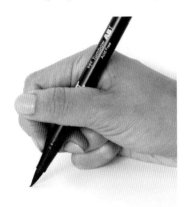 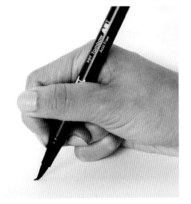 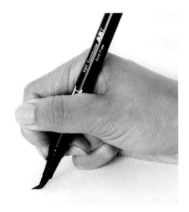

Light pressure Medium pressure Full/heavy pressure

To take advantage of this flexible nib, you must hold the brush pen at an angle as discussed in Chapter 1. By holding the brush pen at an angle, you can use your hand muscles to control the amount of pressure that you apply and use the whole nib, that is, the tip and the side of it. By using light pressure, you can use the side of the very tip to make thin upstrokes. For downstrokes, you exert much more pressure onto the nib, causing it to bend, and thus allowing the side of the nib to make contact with the paper, creating a thick stroke. If you hold the brush pen at an angle more perpendicular to the paper, then not only will you be able to achieve a lesser variety of stroke widths, you will fray the nibs much faster.

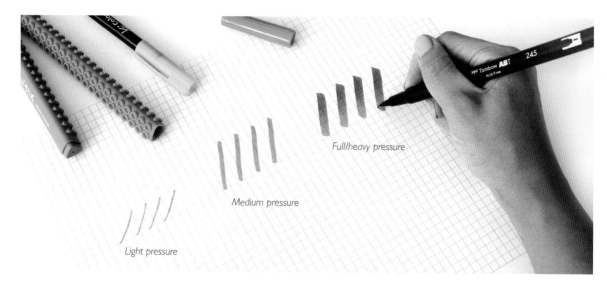

Full/heavy pressure

Medium pressure

Light pressure

Experimenting with pressure is crucial in getting to know your brush pens. As each brush pen is different, take some time applying different amounts of pressure to each pen. You can start off by applying the lightest pressure possible and filling a half to a whole page with upstrokes. Then you can apply a moderate amount of pressure to create thick downstrokes. Fill a half to a whole page to get the feel of how much pressure is required to create that particular stroke. Now try using much more pressure to create even thicker downstrokes. Again, fill a half to a whole page with these strokes. Now, step back and look at the variety of strokes that you created. Notice how thin you can go on the upstroke and how thick you can go on the downstroke.

Guidelines

Before we move on, we need to get technical with terminology. By familiarizing yourself with these terms, it'll be easier to understand the explanations in this guide and communicate with others who share a love for lettering, too.

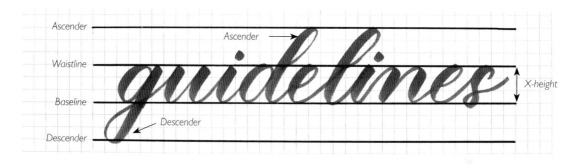

The diagram on page 12 demonstrates a set of terms that will be essential to learning more about individual letters and guidelines for keeping your letters proportioned. The **x-height** refers to the height of a letter's main body, not including ascenders and descenders (i.e., the space between the waistline and baseline). The **waistline** is the line that goes across the top of a letter's x-height, not including ascenders. The **baseline** is the line that goes across the bottom of a letter's x-height, not including descenders. The **ascender** is the part of the letter that extends above its x-height, such as in lowercase b, d, and h. The **descender** is the part of the letter that extends below its x-height, such as in lowercase g, j, and p. In lettering samples throughout this book, I've labeled the waistline with W, the baseline with B, the ascender line with A, and the descender line with D.

The Basic Strokes

The basic strokes on their own are a series of straight and curved strokes that vary in thickness. As unassuming as they are, be careful not to underestimate them because they are the key to building a strong foundation on which to build your skills. Though you may be tempted to letter words and phrases right now, it is extremely important to spend some quality time with your brush pens and practice the basic strokes until you have much control over them.

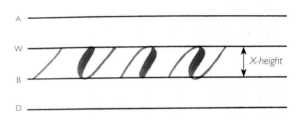

From left to right: entrance stroke, underturn, overturn, and compound curve.

All the letterforms are formed by a combination of two or more of these basic strokes. It is unlike handwriting in cursive in that instead of forming a letter in one fluid motion, you draw the strokes one by one and lift your brush pen off the paper in between. Think of the strokes as separate shapes

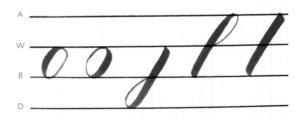

From left to right: oval, reverse oval, descending stem loop, ascending stem loop, and full-pressure stroke.

that you piece together like a puzzle to make letters. This is why it is not necessary to have good penmanship in order to be successful at lettering. Making this simple but profound mind-shift—that lettering is not writing, it is drawing—will have a great impact on your progress. This mind-shift, coupled with a solid understanding that the basic strokes are the building blocks of letterforms, will make you a stronger lettering artist.

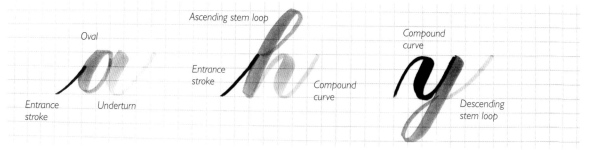

All letterforms are a combination of two or more basic strokes.

Diving into lettering by working on words and phrases first can quickly become overwhelming and, more likely than not, the results can be disappointing.

- By focusing on the building blocks of lettering and intentionally working on your form, you will be able to better see what can be improved.

- Knowing where and how you can improve your strokes leads to a more efficient way of practicing.

- Focusing on mastering one stroke at a time will help you build muscle memory to a point where you will not have to think about how to create it.

- In turn, building muscle memory with your strokes will also lead to consistency.

By starting small, with the basic strokes, and practicing on a consistent basis, you will be able to progress at a faster rate. It seems counterintuitive, but building good habits now and having a solid understanding of how the letters are formed will enable you to move onto lettering words and phrases with much more success and less frustration along the way!

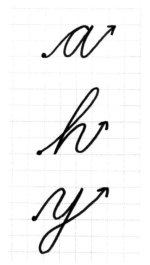

You do not lift the pen at all while handwriting in cursive unless crossing the letter t or dotting the letter i.

Let's take a closer look at the basic strokes. You will see how each one fits within the guidelines. There is a detailed description of how to create the basic stroke followed by some nonexamples. The nonexamples are meant to help you decipher what is going on with your form and gain a better understanding of how you are handling the brush pen. That way you can make the necessary adjustments to your approach, whether that be related to grip, angle, or pressure, and be on your way to more consistent, well-formed strokes.

The entrance stroke. The entrance stroke is so deceiving; it's harder to pull off than it looks! But don't worry about being perfect. Consistency with this stroke will occur over time if you put in the time to practice it (I promise!). This stroke is used at the beginning of a letterform and is essential for connecting one letter to another. (This stroke is also used at the end of a letterform and is referred to as an exit stroke.)

Start at the baseline and with consistent, light pressure, move toward the waistline with a slight curve, stopping right at the waistline.

The underturn. Next is the underturn, which is found in lowercase letters, such as a, i, u, and w. The underturn is essentially u-shaped. It starts off as a thick downstroke and transitions into a thin upstroke.

To create the underturn, start off with full pressure at the waistline, then as you move toward the baseline, gradually release pressure. By the time you hit the baseline, you should be using light pressure to create a thin line. To ensure that your stroke is thin by the time you hit the baseline, start to release the pressure about two-thirds of the way down. Then you continue upward with the same light pressure until you hit the waistline. The latter half of this stroke is basically an entrance stroke.

The underturn is also found in lowercase letters d and t, except the stem is taller. For these you would start a full-pressure stroke at the ascender line and then continue as you would for a regular underturn.

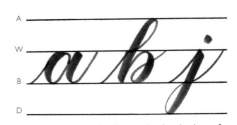

The entrance stroke forms the beginning of lowercase letters, such as a, b, and j.

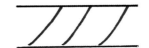

Examples of correct entrance stroke form.

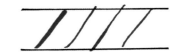

Common entrance stroke mistakes (left to right): too thick, shaky, uneven pressure/ outside of guideline, and changing slant.

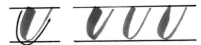

Underturn examples (left to right): correct, bottom heavy, less contrast between thick and thin strokes, uneven pressure on downstroke.

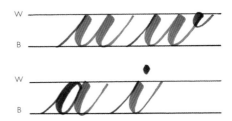

The underturn can be found in the middle or can be the final stroke in lowercase letters, such as a, i, u, and w.

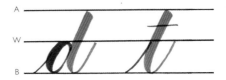

The stem of the underturn (downstroke) is longer in simpler forms of lowercase d and t.

The overturn. The overturn is found in lowercase letters such as m and n. It is the direct opposite (upside-down version) of the underturn, starting off as a thin upstroke and transitioning into a thick downstroke.

Instead of starting with full pressure, you start with light pressure at the baseline, move upward, continuing with constant, light pressure until you hit the waistline, then curve downward, gradually increasing the pressure to finally hit the baseline at full pressure. The key to this stroke is to increase the pressure only after you have hit the waistline and curved around.

The compound curve. The compound curve is a combination of the overturn followed by an underturn. It is used in lowercase letters, such as h, m, n, v, x, and y.

Start at the baseline with light pressure, continue upward, keeping the pressure constant, hit the waistline, and curve around. Once you start moving downward, gradually add pressure until you reach full pressure at the midway point between the waistline and baseline. As you continue moving downward, gradually release the pressure until you reach the baseline again with a thin line. Curve back upward with constant, light pressure until you hit the waistline.

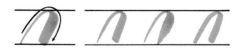

Overturn examples (left to right): correct, uneven pressure on upstroke, uneven pressure on downstroke, not enough contrast between thick and thin strokes.

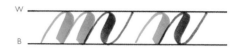

The overturn forms the beginning of lower case m and n.

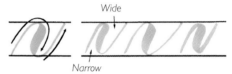

Examples of compound stroke (left to right): correct, uneven negative space between thin and thick parts of the stroke, thin strokes are not parallel, not enough contrast between thin and thick parts of the stroke.

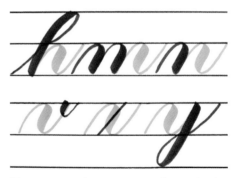

The compound curve appears first or last in these letters.

The oval. The oval is used for lowercase letters a, d, g, o, and q. To produce the oval, start at the 2 o'clock position.

Oval examples (left to right): correct, loop is not closed, not enough contrast between thin and thick parts of the stroke.

Begin with light pressure and turn counterclockwise. After you hit the waistline and curve downward toward the left, start increasing the pressure until you hit full pressure about midway. After the midway point, gradually decrease the pressure until you hit the baseline with a thin stroke. Continue by curving toward the right with constant, light pressure until you close the loop. The thickness of the thin stroke that starts and ends the loop should be the same.

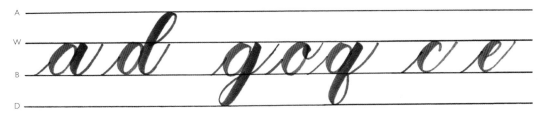

The oval appears as the second stroke in each of these letters. A variation of the oval is used for lowercase c and e. It does not close but transitions into an exit stroke that is parallel to the entrance stroke.

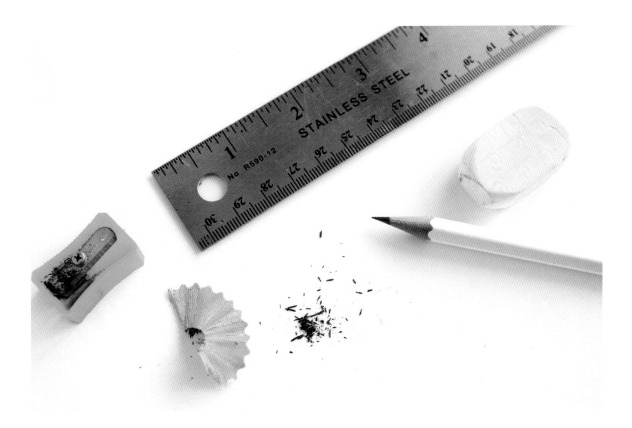

The ascending stem loop. The ascending stem loop is used in lowercase letters b, d, f, h, k, and l. It forms any part of a letter that extends above the waistline.

The ascending stem loop starts at the waistline with light pressure. You curve up toward the ascender line. As you come around and move counterclockwise, start increasing pressure. The remaining two-thirds of this stroke is completed at full pressure all the way to the baseline.

The descending stem loop. The descending stem loop is found in the lowercase letters g, j, p, and y. It forms any part of a letter that extends below the baseline.

The descending stem loop starts at the waistline with full pressure. As you move downward, start releasing the pressure after you cross the baseline. Keep going until you hit the descender line with a thin line. Move clockwise with a thin stroke and continue upward with constant, light pressure until you reach the baseline.

Examples of ascending stem loop (left to right): correct, loop is collapsed, gap between thin and thick parts of the stroke, curved downstroke.

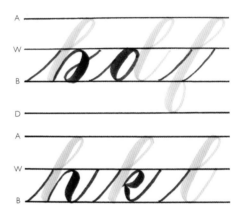

The ascending stem loop is found in these letters but note that in lowercase d, the ascending stem loop transitions into an underturn. In the lowercase f, it transitions into a reverse descending stem loop.

Examples of descending stem loop (left to right): correct, transitioning too early from thick to thin, not enough contrast between thick and thin parts, loop is too small and does not breath.

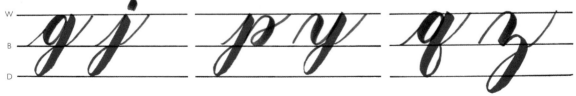

The descending stem loop in the lowercase g, j, p, and y. Note that for the lowercase q, the descending stem loop is reversed and therefore curves to the right. For the lowercase z, the descending stem loop transitions from an overturn.

The full-pressure stroke. The full-pressure stroke is basically a thick downstroke created by pressure that is applied heavily and evenly throughout. You'll find the full-pressure stroke as a part of other strokes, such as the ascending and descending stem loops, except it is consistently wide from top to bottom; there is no transition to or from a thin stroke.

Examples of full-pressure stroke (left to right): correct, uneven pressure and rounded top, uneven pressure and rounded bottom.

Start at the ascender line at full pressure, pull down, keeping the pressure constant, and lift at the baseline (or start at the waistline and end at the descender line).

The Odd Ones Out

The full-pressure stroke in simpler forms of lowercase letters like b and p.

I would like to be able to tell you that the basic strokes are all you need to make all the letters of the alphabet but that would be too easy. Everyone loves a challenge, right? Some of the lowercase letterforms require you to draw other strokes that are variations of the basic strokes already described. Let's get right down to business. Note that the "other" strokes are created in color while the basic strokes are gray.

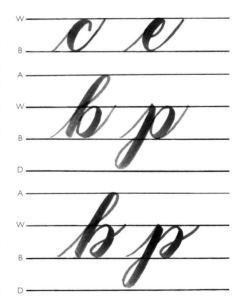

The lowercase c and e essentially require you to draw a variation of the oval. With the letter c, the oval begins in the same manner but instead of closing the loop, you veer toward the right as if you are drawing an exit stroke. The second stroke of the letter c is, therefore, a hybrid of the oval and the exit stroke. For the letter e, the second stroke begins where the entrance stroke ends, eventually creating a loop. Then, after hitting the baseline, you veer toward the right, drawing an exit stroke.

In their simplest versions, the lowercase b and p can be drawn with a reverse oval. To add this stroke, place the tip of the brush pen on the right side of the ascending stem loop midway between the baseline and waistline. Using light pressure, curve upward and clockwise, apply pressure coming around, then transition back to light pressure just before hitting the baseline. Finally, go back to where you started, closing the oval.

In the version I use the most, the letters b and p are drawn with a variation of the reverse oval. It starts as described above but instead of closing the oval, you bring the thin stroke around, creating a loop, then going straight through the oval to the other side. Going through to the other side creates an exit stroke that allows you to connect to another letter.

Let's talk about the lowercase q first. In this letter, the descending stem loop is reversed. So instead of curving toward the left at the descender, you curve toward the right and close the loop at the baseline.

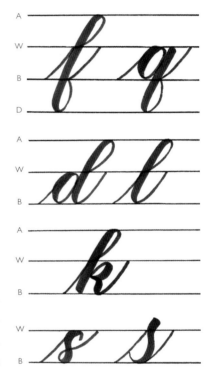

The lowercase f starts with an ascending stem loop then transitions to a reverse descending stem loop. It is a hybrid of the two. Instead of stopping at the baseline, you keep going to the descender then curve toward the right and close the loop at the baseline, as in the letter q.

The letters d and l begin with an ascending stem loop then transition directly into an underturn. It is a hybrid of these two basic strokes. After you create the loop, be prepared to gradually lighten the pressure before hitting the baseline. Then keep going with light pressure all the way to the waistline to finish the underturn.

Lowercase k has two other strokes that we need to talk about. The first looks like a rabbit's ear. You start at the right side of the ascending stem loop midway between the baseline and the waistline, then move upward with light pressure until you hit the waistline. Curve around and transition into a thick downstroke, then quickly lighten up again on the pressure to go back to where you started. Imagine it to be a squished reverse oval!

The next stroke starts exactly where you left off with the previous stroke, i.e., the rabbit's ear. You start with light pressure moving across, then apply heavy pressure downward toward the baseline following the same slant as the rabbit's ear, then continue as if you are drawing an underturn. With light pressure, go all the way to the waistline.

The version of lowercase s I use the most is on the left. The stroke is done in one motion, starting like a regular oval then ending like a reverse oval. Start with light pressure, curve counterclockwise, increasing the pressure, make a shift toward the right, keeping the same (heavy) pressure, then curve around clockwise, lightening up on the pressure by the time you hit the baseline. Continue with a thin stroke

veering toward the right, going through the stroke to the other side, reaching the waistline and allowing you to connect to another letter.

Another common version of the letter s starts with heavy pressure above the waistline (about midway between the waistline and the ascender) and shifts over to the right, curving around like a reverse oval. It ends when it hits the entrance stroke, above the baseline. This stroke has an s-like shape to it.

The lowercase x is essentially a compound curve with a thin line cutting through the middle of it. The version on the left has an adjusted compound curve where the downstroke is drawn perpendicular to the guidelines (instead of at the same slant as the upstrokes) so that when the thin line cuts through it, the x appears more clear. Use light pressure and draw a straight line following the slant of the upstrokes starting at the baseline and ending at the waistline. The version on the right is made up of a regular compound curve. However, the line that cuts through it is drawn as a wave that looks the same on either side (i.e., it is symmetrical).

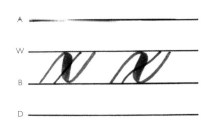

For the lower case z, the stroke in question starts at the baseline on the right side of the previously drawn overturn. You start like an overturn, curving upward to a third of the way between the baseline and the waistline then transition to a descending stem loop that goes past the descender. Extending past the descender makes the letter appear more elegant.

Guidelines for Practicing

I've included a set of guide sheets for you to use during practice. The guide on page 111 has lines spaced 15 millimeters apart (i.e., the x-height equals 15 millimeters, which is set up to use with large-tipped brush pens. The guide on page 109 has lines spaced 7 millimeters apart (an x-height of 7 millimeters) and is suitable for use with the small-tipped brush pens. Because tracing paper and marker paper are translucent, you can place these types of paper directly onto the book and can still see the strokes showing through to trace them.

1. For each practice session, choose one of the basic strokes to focus on.

2. Try tracing the first few until you get the hang of it and then try lettering the stroke on your own.

3. Fill a page or two to get a feel for it. Right now, it may take a lot of concentration, but the goal is to build muscle memory so that down the road, you'll be able to create these strokes without even thinking. You also may experience shakiness and that is completely normal! The more you practice, the stronger your muscles will become and the more control you'll develop over the brush pen.

Ready for more? Let's work on some drills.

Drills and Making Connections

Drills are exercises that target a specific skill or concept. In the case of lettering, drills will help you build muscle memory and develop consistency for each of the basic strokes. Each drill requires you to repeatedly draw the same stroke or series of strokes. They start off simple and gradually get more challenging. You can choose to follow the progression of these drills or just do specific ones to target areas of your lettering you want to improve. Although they are shown in one single line, it is highly encouraged that you fill a whole page or more of each type of drill (but not necessarily all in one sitting). Use them as the basis for your practice sessions. Drills will help you to remember how a stroke looks, how it feels in your hand to draw it, and how and when to apply pressure. Over time, these drills will help you lay a strong foundation—once you learn the basic strokes and handle them well, then whole letters, words, and phrases will be easier to letter.

Drills are excellent for warming up as well. At the start of each practice session, spend a few minutes warming up your muscles with these drills so that you'll experience less shakiness and stiffness in your hand.

Finally, drills are a great way to get to know a new brush pen. Each brush pen is slightly different (see Chapter 1). By doing drills, you will get a feel for how flexible the tip is, the range of thin to thick strokes you can achieve with it, and how it compares to the ones that you are familiar with.

Entrance Stroke Drills

Fill a page or two with entrance strokes. Before you start, ensure that your brush pen is held at an angle, adjust your grip, and angle your paper. Take small breaks in between if you start to feel cramping. Those are your muscles getting used to the movement!

Entrance strokes

Entrance stroke and short full-pressure stroke: This time, create the entrance stroke, lift the brush pen, leave a space, then create a short full-pressure stroke. Alternate between these two and make sure to lift your brush pen after each one.

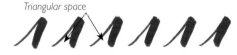

Entrance strokes with short full-pressure strokes

Entrance stroke connected to short full-pressure stroke: Connect the entrance stroke to the short full-pressure stroke (i.e., without leaving a space between the two). You might be tempted to connect these two without lifting in between, but make sure you do. This will keep your strokes

Triangular space

Entrance and full-pressure strokes connected

neat and clean. The full-pressure stroke should connect to the top third of the entrance stroke, leaving a triangular negative space underneath and between the two strokes. If this space is too small, the overall appearance will be stuffy.

Underturn Stroke Drills

Underturn stroke: Fill a page or two with underturn strokes. Take your time and ensure that you gradually lift the pressure well before you reach the baseline. Make it a goal to reach the baseline with the very tip of your brush pen so that you can complete the remainder of the underturn with a thin line.

Underturn stroke

Three connected underturn strokes: Slowly start practicing your connections and building stamina within the muscles of your hand. Lift between each underturn. You'll notice that just before you connect the second and third underturns, you'll need to shift your hand ever so slightly to the right (to the left if you're left-handed) to make a clean connection to the previous underturn. Not doing so will cause your hand to cramp and you may notice that the space in the middle of your underturn strokes will become quite narrow.

Three connected underturn strokes

Connected underturn strokes: Connect the underturn strokes in a single row without any spaces in between. Go slow. Remember to move your hand over slightly before you connect each subsequent underturn to make a clean connection and allow your underturn strokes to breathe. When you connect the next underturn stroke, place the tip of your brush where the previous underturn ended (at the waistline) and follow the slant

Connected underturn strokes

as you go downward with full pressure. The left side of this thick downstroke should follow the slant of the thin stroke of the previous underturn. If you place the tip of your brush pen farther to the left, the strokes will overlap and they will appear squished. If you place the tip too far to the right, then you won't connect at all. As you create each stroke, look at the previous one and try to make an exact copy.

Left: correct form with clean connection and no overlapping. Right: incorrect form with subsequent underturns that overlap previous ones, which results in squishing.

Once you get comfortable with connecting several in a row, you'll notice a rhythm in your movements.

Entrance stroke and underturn stroke: Connect the entrance stroke to an underturn stroke. After each entrance stroke, lift and lay down your brush pen again to connect and create the underturn stroke. The idea is to make it appear that you have not lifted in between when in fact you have. Check to see if the entrance stroke and the thin part of the underturn stroke are parallel to each other.

Entrance stroke and elongated underturn stroke: This drill is like the one above except that the underturn starts at the ascender line. The downstroke becomes twice the height or two x-heights tall. This is essentially the letter t without the crossbar.

Overturn Stroke Drills

Overturn stroke: Fill a page or two with overturn strokes. Be patient and ensure that you stay on the very tip of your brush tip to create a thin line even as you hit the waistline. Right after, gradually increase the pressure to complete the underturn.

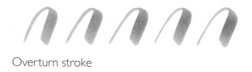

Overturn stroke

Three connected overturn strokes: You are ready for this gradual increase in difficulty. By connecting a few strokes in a row, you will increase the stamina in the muscles in your hand to produce multiple strokes at a time. Lift once

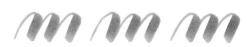

Three connected overturn strokes

after each overturn is complete and shift your hand slightly over to accommodate the full size of the next overturn before placing the tip down on the paper again. Place the tip of the brush pen on the right side of the thickest part of the downstroke of the previous overturn (i.e., start at the baseline). As you move upward with light pressure, move along the slant of that thick stroke to create a seamless connection. If you start the connection closer to the left side of the thickest part of the downstroke, then the spacing will be off. The strokes will look squished against each other and that is not a good look altogether!

Connected overturn strokes: Connect the overturn strokes in a single row without any spaces in between. Take your time. Remember to move your hand over a smidgen before connecting the next overturn. Be mindful of where you are making the connection (i.e., at the right side of the thickest part of the downstroke of the previous overturn). As you move along, make every effort to make your overturns look the same. If it doesn't look right, make an adjustment right away to ensure that you do not reinforce poor form.

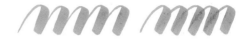

Connected overturn strokes

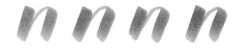

Left: correct form with clean connection and no overlapping. Right: incorrect form with subsequent overturns that start too far left, which results in squishing.

Short, full-pressure stroke and overturn stroke: Connect the short, full-pressure stroke to an overturn stroke. The full-pressure stroke starts at the waistline and ends at the baseline and should be equal in width all the way through.

Short, full-pressure stroke and overturn stroke

To connect the overturn stroke, place the tip of the brush pen at the baseline on the right side of the full-pressure stroke. As you move with light pressure upwards, follow the slant of the full-pressure stroke. Ensure that the full-pressure stroke and the thickest part of the overturn are parallel to each other. Notice that the combination of these two strokes forms a version of the lowercase n.

Full-pressure stroke and two overturn strokes: As in the previous drill, connect the full-pressure stroke with an overturn except add a second overturn stroke. This combination will form a version of the lowercase m. Again, take your time and make sure you connect each stroke at the appropriate spot and check to see if the slants of the strokes are parallel to each other.

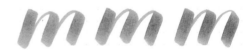

Left: correct form with thick downstrokes that are parallel to each other. Right: incorrect form. Thick downstrokes are not parallel.

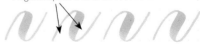

Full-pressure stroke and two overturn strokes

Compound Curve Drills

Compound curve: Fill a page or two with compound curves. This stroke involves two transitions: thin to thick and thick to thin. It is essential to consciously slow yourself down and pay attention to how the pressure applied to the tip is affecting the shape of the curves. The transitions are not abrupt but in fact slow and gradual. Before moving on,

Negative space is even on both sides.

Correct compound curve form. Note the even negative space on both sides of the curves.

check to see if the negative space between the strokes on either side of the thick downstroke is even. Try turning your paper upside down—do your compound curves still look the same?

Incorrect form. Negative space is larger on one side.

Three connected compound curves: When multiple compound curves are connected to each other, the last part of one compound curve acts as the first part of the next compound curve. Because you want to lift between each stroke you will not be able to complete one compound curve before you start the other. To make the connections appear seamless, stop midway between the baseline and waistline when you are making the final thin upstroke. When placing the tip of the brush pen back down on the paper, place it just below where you ended the last stroke and continue to go upward. Transition to a thick downstroke, completing the next compound curve. This will make it appear that the compound curves are blending in with each other rather than having obvious breaks in between. Although compound curves are rarely connected to each other (it depends on one's style), this drill will help you to develop control over your brush pen.

Three connected compound curves

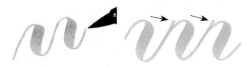

Stop midway and lift before connecting next compound curve.

Fully completing the compound curve to the waistline before connecting the next leaves the end jutting out.

Five connected compound curves: When you become comfortable with the above drill, try this one where you connect five in a row. Check for consistency. Are the spaces between the strokes even? Do you hit the baseline and waistline every single time? Do your connections appear seamless?

Five connected compound curves

Overturn stroke and compound curve: Connect the overturn stroke to the compound curve. When you lift after making the overturn stroke, place the tip back down on the paper on the right side of the thick downstroke down at the baseline. Move upward along the slant of this downstroke to make the compound curve. This combination of strokes makes another version of the lowercase n.

Overturn stroke and compound curve

Two overturn strokes and a compound curve: This drill is like the previous one except you connect two overturn strokes in a row before adding the compound curve. This

Two overturn strokes and compound curve

combination of strokes produces another version of the lowercase m. To ensure consistency, check the amount of space between the strokes and that the slant is consistent all the way through.

Oval Drills

Oval: Fill a page or two with ovals. Remember to start at the 2 o'clock position with light pressure then transition to heavy pressure as you turn counterclockwise. Aim to close the loop completely.

Oval with loop completely closed

Entrance stroke and oval: Connect the entrance stroke to the oval. When making the entrance stroke, do not go all the way to the waistline. This time stop about two-thirds of the way. Because the oval is rounded, if the entrance stroke goes all the way to the waistline, it will not connect well to the rounded edge of the oval. To connect the oval, you should place the tip of your brush pen far enough to the right so that the left edge of the oval connects directly to the entrance stroke. It may take a bit of time to understand where exactly to start the oval because you must know how large it will be. If you end up overlapping the entrance stroke, you should start the oval farther away. If you start too far away, you will not connect with the entrance stroke at all. It will get easier with practice and the building of muscle memory. Visualizing just how large the oval is before actually creating it will help you decide where to place the tip of your brush pen.

Entrance stroke and oval

To avoid an unsmooth connection, stop the entrance stroke about two-thirds of the way, indicated by the arrow.

Entrance stroke, oval, and underturn stroke: This drill is one step above the previous one in that you now connect an underturn stroke to the combination. Connecting an underturn stroke to an oval will take visualization as well. When you begin an underturn, you apply full pressure immediately to make a thick downstroke. Knowing just how thick this stroke is will ensure that the tip of the brush pen overlaps the thin side of the oval. That is, the left side of the thick downstroke of the underturn just kisses the side of the oval. If the underturn starts too close to the oval, the space in the center of the oval will be compromised. This combination of strokes produces the lowercase a.

Left: clean connection. Right: oval negative space is compromised where underturn overlaps oval.

Left: visualize the oval (in gray) and place your tip as shown. Right: visualize the underturn (in gray) and place tip as shown; apply full pressure for stroke.

Entrance stroke, oval, and elongated underturn stroke: This drill is the same as above except the underturn starts at the ascender instead of the waistline. This makes it two x-heights tall. Before placing down the tip of your brush pen on the paper to make the underturn, visualize where you want the stroke to land. Remember that the left side of this thick downstroke should just kiss the side of the oval and not overlap it completely. This combination of strokes produces one combination of the lowercase d.

Left: entrance stroke, oval, and elongated underturn stroke. Right: visualize the elongated underturn (in gray) and place tip as shown; apply full pressure for stroke.

Entrance stroke, oval, and mini underturn stroke: In this drill, you will add a smaller version of the underturn stroke to make one version of the lowercase o. It will not take as much

pressure to create this underturn as your regular-sized one because it is smaller. Note that the thick portion of this mini underturn lands on the inside of the oval and the right side of the thick part touches the thin stroke of the oval. End this mini underturn stroke at the waistline.

Connecting ovals with mini underturn strokes: Connect a series of ovals together with a mini underturn stroke in between. Because you will connect the mini underturn with

an oval, do not go all the way to the waistline. Instead, stop just below it so that the connection between the mini underturn and the following oval will be seamless. Go slow at first and notice the alternating amounts of pressure required to create the oval and then the mini underturn. As you move across the paper, a natural rhythm will occur in your strokes.

Ascending Stem Loop Drills

Ascending stem loop: Fill a page or two with ascending stem loops and aim for consistency. Check out the size of the loop and make sure the spacing inside is the same for each one. Make sure that you start at the waistline then hit the ascender and the baseline every single time. Taking the little details into consideration increases consistency, and that will help you in the long run!

Ascending stem loop

Entrance stroke and ascending stem loop: Connect the entrance stroke to the ascending stem loop. When starting the ascending stem loop, place your tip where the entrance stroke ended. As you move upward with light pressure, move far enough to the right to make the loop. Coming down to make the thick part of the ascending stem loop will require

Entrance stroke and ascending stem loop

you to anticipate when and where to start increasing pressure. You will want the left side of the thick part of the stroke to hit the end of the entrance stroke at the waistline, not overlap it.

Entrance stroke, ascending stem loop, and compound curve: This drill is the same as above except now you connect a third stroke, the compound curve. When you connect the compound curve, place the tip at the baseline on the right side of the thick part of the ascending stem loop. Ensure that the slant of your strokes are parallel to each other. This combination of strokes forms the lowercase h.

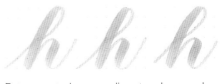

Entrance stroke, ascending stem loop, and compound curve

Entrance stroke and ascending stem loop that transitions to an underturn stroke: In this drill, the bottom of the ascending stem loop becomes an underturn. In other words, the second stroke of this combination is a hybrid of the ascending stem loop and the underturn. Instead of coming down with full pressure all the way to the baseline, you transition to light pressure and make the underturn going back to the waistline. Take note of the slant of the entrance stroke and the thin part of the underturn—are they parallel? You are well on your way to making the lowercase l!

Left: loop goes far enough to the right to give space to the downstroke that just touches the entrance stroke. Right: the downstroke is overlapping the entrance stroke.

Entrance stroke and ascending stem loop that transitions to an underturn stroke

Descending Stem Loop Drills

Descending stem loop: Fill a page or two with descending stem loops, and aim for consistency. Ensure that the thick part of this stroke is even throughout except when you start transitioning into the loop. Check to see if the size of the loop is the same each time. If it is too narrow, push the tip of the brush pen farther out to the left to widen the loop. Close the loop every time at the baseline.

Descending stem loop

Entrance stroke and descending stem loop: To connect the descending stem loop to the entrance stroke, place the tip of your brush pen where the entrance stroke ended and then apply full pressure. This will make sure the top of the descending stem loop does not overlap the entrance stroke.

Entrance stroke, descending stem loop, and exit stroke: This drill is the same as above except another entrance stroke is added at the end; hence, an exit stroke. To add the exit stroke, start at the baseline while just touching the right side of the descending stem loop. It should appear that the thin part of the loop is just continuing through to the other side of the descending stem loop. This combination of strokes produces the letter j without the dot at the top.

Oval and descending stem loop: Connect the oval and the descending stem loop. Visualize where to place the tip of the brush pen before setting it down on the paper to make the descending stem loop. You want to make sure that the left side of the descending stem loop makes an elegant connection to the right side of the oval, not overlapping it.

Full-Pressure Stroke Drills

Full-pressure stroke: Fill a page or two with full-pressure strokes. Remember, start at the ascender and apply full pressure before you even begin moving down toward the left at an angle to the descender. This stroke is two x-heights tall. Aim to have consistent width from top to bottom by applying the same amount of pressure from beginning to end. If you don't, you will have tops or bottoms with rounded or tapered ends. Don't be afraid to apply a lot of pressure to get that thick stroke.

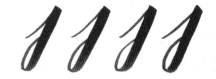

Entrance stroke and descending stem loop

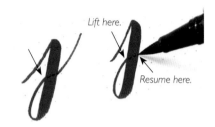

Left: entrance stroke, descending stem loop, and exit stroke. Note the arrow: the thin part of the loop appears to continue through the downstroke and all the way up to the baseline. Right: lift the tip of the pen before overlap. Resume as indicated to draw the exit stroke.

Oval and descending stem loop

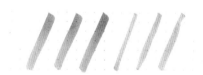

Full-pressure stroke

The first three strokes show even, heavy pressure from top to bottom. The last three strokes demonstrate uneven pressure throughout.

Entrance stroke and full-pressure stroke starting at the ascender: Connect the entrance stroke to the full-pressure stroke. The left side of the full-pressure stroke should just touch the end of the entrance stroke at the waistline. Visualize how thick the stroke will be so you know where to place the tip of the brush pen or once you end the entrance stroke, lift the tip and keep moving it toward the ascender, imagining that the entrance stroke is extending toward this line. Then, at the ascender, do not move your hand left or right, but simply place the tip of your brush pen back down. When you make the full-pressure stroke, the left side of the stroke where your tip is should just touch the end of the entrance stroke. Keep moving and stop at the baseline. Look back at your strokes and check the triangular space underneath the connection and see that they are relatively the same size. The entrance stroke should hit the full-pressure stroke at an angle rather than perpendicular to it.

Entrance stroke and full-pressure stroke starting at the ascender

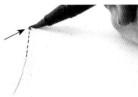

Move tip in the air to this point, then place down with full pressure.

Entrance stroke and full-pressure stroke starting at the waistline: This combination is the same as the above drill except the full-pressure strokes starts at the waistline and ends at the descender. To connect the full-pressure stroke to the entrance stroke, place the tip of the brush pen right where the entrance stroke ended. This combination of strokes works for the lowercase p.

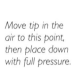

Entrance stroke and full-pressure stroke starting at the waistline

Entrance stroke, full-pressure stroke, and compound curve: For this drill, start the full-pressure stroke at the ascender. Once you connect these three strokes together, look at the thick parts and see if they are parallel to each other. Notice that this combination of strokes produces one version of the lowercase h.

Entrance stroke, full-pressure stroke, and compound curve

Troubleshooting

Shakiness

Warm up: Before you exercise, warming up the muscles via stretching can help you ease into any sort of physical activity. With brush lettering it's the same thing. If you experience a lot of shakiness, consider warming up the muscles in your hands by doing some stretching exercises. Another way to warm up the muscles is by taking a pencil and repeatedly drawing various-sized loops in different directions on a scrap piece of paper. Be creative and let loose! Try large loops that involve moving your whole arm from the shoulder. Try others that loosen the wrist. Finally, try smaller loops that require small finger movements.

Avoid caffeine: If you're like me, I get in the zone with brush lettering with a coffee by my side. Because I can't (read: won't) give up coffee, I understand that caffeine can affect how smooth my strokes turn out. You can have more willpower and just avoid caffeine during practice altogether!

Give full attention to specific strokes: Take a moment to reflect on how you've been practicing so far. Have you sat down and practiced a variety of strokes in one sitting or have you focused on just one stroke? Slow down and focus just on one stroke for today. By intently practicing to improve this stroke, your muscle memory will improve and you'll develop more control over the brush tip.

Switch between light and heavy pressure: So, I just advised that spending time on focusing on just one stroke will help. However, I also believe that alternating between drawing the entrance stroke and full-pressure strokes helps as well. By switching between an entrance stroke (with the lightest pressure possible) and a full-pressure stroke (with the heaviest possible pressure), you will "feel" the difference in pressure required to create a thin upstroke and therefore be able to quickly switch between the two with more ease over time. This will also help with making transitions to thin and thick strokes and vice versa.

Use your whole arm: Remember that moving the brush pen up and down, and back and forth, requires the fingers to stay static. Movement should be generated at the wrist with the forearm muscles flexed. For even larger movements, move your whole arm, only rotating at the shoulder. This will result in smoother lines.

Be patient: Understand that shakiness will diminish over time with practice as you develop more control. But don't be surprised if it creeps up on you from time to time due to stiffness in the muscles or if you have had a longer-than-intended break between practice sessions.

Embrace the imperfections: The charm of hand lettering is partly due to the slight imperfections that you see! It will never be perfect but it will be unique and totally yours to own.

Upstrokes Are Too Thick

Go slow: It seems counterintuitive, but moving quickly does not necessarily produce a smooth stroke. Slow down and maintain control over the tip as you glide it across the paper.

Focus on consistency rather than thinness: Trying to achieve the thinnest possible stroke (referred to as a hairline) may be quite frustrating. As a beginner, try focusing on consistency instead. When you focus on consistency, you build muscle memory. When you build muscle memory, you will realize one day how little you need to think while making an upstroke.

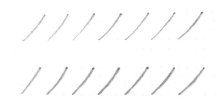

Top: consistently thin upstrokes. Bottom: thicker upstrokes but still consistent.

Understand that different brush pens can produce a different range of thin to thick strokes: With the same light pressure, a large-tipped pen will likely produce a thicker upstroke than a smaller-tipped brush pen due to its size. Even within a group of large-tipped brush pens, each will produce a slightly different thickness due to the size of the tip. Get to know your brush pens. Take one brush pen and play around with different pressures by first starting with the lightest pressure possible and gradually building pressure to produce the thickest downstroke possible. What is the minimum thinness you can achieve? By the same token, what is the maximum thickness you can achieve? Then, take a different brush pen

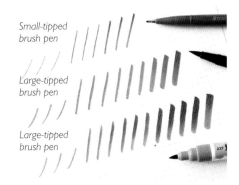

Small-tipped brush pen

Large-tipped brush pen

Large-tipped brush pen

Even within a group of large-tipped brush pens, each will produce a slightly different thickness due to the size of the tip.

and do the same. Compare the range of strokes that is produced by each of the brush pens and notice that they will be a little different. So, don't beat yourself up. The size of the tip will determine the range of stroke widths you can create.

Aim for contrast between your upstrokes and downstrokes: Instead of focusing on trying so hard to produce a hairline, don't forget to add full pressure to your downstrokes! Making them thicker will make your upstrokes appear thinner.

Rounded Tops or Bottoms on Downstrokes

If you notice tapering or rounding of the tops of the underturn, descending stem loop, and full-pressure stroke, you are moving down the paper before applying full pressure. Place the tip of the brush pen down, apply full pressure so that the side of the nib is touching the paper, then move down, keeping

the pressure heavy and constant. Before any movement occurs, the side of the nib should be touching the paper.

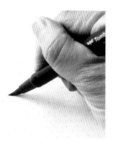

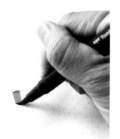

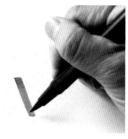

Place the tip of the brush pen down and apply full pressure.

Pull down with constant, heavy pressure.

Complete the stroke with the same amount of pressure.

Lift the tip of the brush pen (do not drag at the same time).

If you notice the same issue on the bottoms of the overturn, ascending stem loop, and full-pressure stroke, you are gradually lifting pressure before you complete the stroke. Fully complete the stroke while the side of the nib is still touching the paper, then lift off. In other words, do not gradually lift the pressure when that part of the stroke should be at its widest.

Transitioning from Thick to Thin (Bottom Appears "Heavy")

Lighten up on pressure before you reach the baseline: For the underturn stroke and the oval, for example, intentionally start lightening up the pressure about two-thirds of the way down. You should hit the baseline with the very tip of the brush producing a thin line. Then, continue with the same light pressure to finish off the stroke.

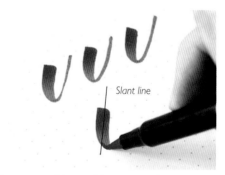

As you transition to light pressure, keep the tip of the pen at a constant angle (i.e., perpendicular to the slant line), drag it slightly across the baseline and then curve upward.

Keep the tip of the pen at a constant angle relative to the paper and drag it across the baseline: Keeping the wrist in a neutral position (not bent), slowly transition into a thin stroke and drag the tip ever so slightly on the baseline before curving upward toward the right.

Transitioning from Thin to Thick

For the overturn stroke, compound curve, and ascending stem loop, increase the pressure to make a thick downstroke only after you hit the waistline and curve around.

It may be helpful to allow yourself to make the transition over a larger area. So, practice drawing the strokes wider or larger at first. Gradually draw them smaller until you get the desired size.

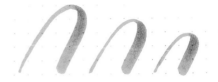

Draw the strokes at a larger size, giving yourself more space to make the transition. Gradually reduce to the desired size.

Inconsistent Strokes

Focus on one stroke per practice session: By honing in on one stroke, you can better observe the issues you are having without being distracted by any inconsistencies you are seeing with a page of all different sorts of strokes.

Pause and reflect: You are focused on one type of stroke and are committed to filling a whole page. But slow down even further. Create a few strokes, then pause and reflect on how you are doing. What are you noticing about your strokes? Jot down what you would like to improve. Is it the thickness of your downstroke, the thinness of your upstroke, the size or the slant of your stroke? When you continue making strokes on the page, intentionally work on the issue at hand. Don't practice mindlessly. It is better to fill a few lines of your best attempts than to fill a page and realize that you've lost focus and control. Once you feel that you have handled one issue, focus on another in the same manner. Take the time to reflect on your practice to inform what areas to focus on going forward. You will make more progress this way.

Use guidelines: Guidelines are essential when you are first learning because they help you to keep your strokes consistent in size. Not only will muscle memory allow you to achieve the desired shape, it will help you create the same size consistently as well. Guidelines are even helpful for the experienced letterer, so don't feel discouraged if it is something that you need to use. In fact, it is highly recommended.

Inconsistent Slant

Use a blank guideline sheet with slant lines: Using a guide ensures consistency. You can use the one provided on page 109 or create your own. Place translucent paper such as tracing paper on top of the guideline sheet and pay attention to the slant lines to guide your practice. You can draw directly on the

slant line (for thin upstrokes) or draw adjacent to it (for thick downstrokes) using the tip of your brush pen to follow along.

With practice, you may be able to get away without using a guideline sheet for keeping a consistent slant specifically. (However, I still recommend using guidelines, in general, to ensure your forms are consistent in size.) In this case, you can use your previously drawn strokes to guide the slant of subsequent strokes. Look at the stroke that you just created then draw a stroke next to it, following the same slant as the previously drawn stroke. This leads to more consistency.

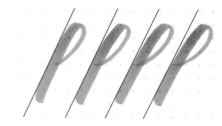

Look at the slant of the previous stroke as a guide to help you draw the next stroke with the same slant.

Uneven Negative Space

Negative space is the space created around and between parts of the basic strokes. If the amount and shape of negative space is uneven when you look at several strokes in a row, it's time to slow down and make a conscious effort to be consistent. When you make the effort to make consistently sized strokes, the negative space created should also be consistent in size.

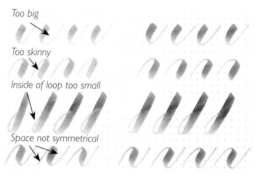

Too big

Too skinny

Inside of loop too small

Space not symmetrical

Uneven negative space Even negative space

Lack of Contrast between Upstrokes and Downstrokes

Don't be afraid to apply pressure: If you notice that there isn't enough contrast between your upstrokes and downstrokes, try focusing on applying the maximum pressure allowed when creating downstrokes. When you normally write with a pen or pencil, you are used to applying similar amounts of pressure whether you are moving up, down, left, or right. But with a brush pen, a great difference of pressures is required and, thus, you need to be intentional about the amount of pressure being applied on the downstroke. Be bold and just experiment with how wide you can go!

Light
pressure

thick

Medium
pressure

thicker

Heavy
pressure

thickest

How differences in pressure affect thickness of downstrokes

Check your grip placement: To apply differing pressures effectively, your grip should neither be too low nor too high. A grip that is just right will be one where your fingers can manipulate the pen and lift the tip for upstrokes and move it down into the paper to bend the tip so that the side of it makes contact with the paper for thick downstrokes.

Check the angle of your grip: While holding the brush pen, check to see that the end of the pen is not pointing directly to the ceiling. Although you will be able to make marks on paper, it will be difficult to apply different pressures to create different thicknesses in your strokes. Change your grip so that the brush pen lies at an angle relative to your paper so you can take advantage of the whole tip, the very end of it, and its side (see How to Grip a Brush Pen on page 8).

Drills for Developing Control

So far you have been working on drills that help you build muscle memory and consistency. The following drills will help you develop control of the brush pen itself. They involve transitions from thick to thin strokes and vice versa. Although each drill is shown on one line, you can choose to do several lines, or even fill a page.

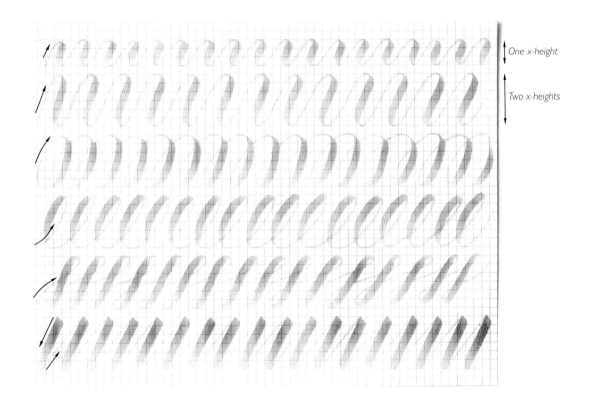

One x-height

Two x-heights

These drills are perfect for helping you to develop whole-arm movement as well. Apart from the first drill, all the drills are two x-heights tall. Using your wrist to do these drills will cause strain and it will be difficult to move across the paper as you need more space. Keep your wrist aligned with the forearm and move the whole arm at the shoulder. This will help you to make larger movements across the paper in a smooth manner. One of the hardest parts will be to aim for consistency in height, weight of strokes, and spacing. As you might be able to tell, creating the loops of consistent size was the most difficult for me. Even with experience, it doesn't hurt to spend time on developing control.

Just like the previous drills used to practice the basic strokes, you can also use these to warm up your muscles for a practice session or to break in a new brush pen and find out how it performs.

CHAPTER 3

Getting to Know Your ABCs

Letterforms

What is a letterform? A letterform is a term used to refer to a letter's shape. The following pages demonstrate how to form the letters of the lowercase alphabet with each line showing the order of the strokes needed to form the letter. While spending some time with the drills in Chapter 2, you will have noticed that most of the letters are formed with the basic strokes as they are. A few letters, such as c, f, k, and q, are made up of strokes that are a variations of basics strokes. This particular lowercase alphabet is a simple script that can be used as a base to grow from. Once you get comfortable with these letterforms you will be able to alter them to suit your own creativity and style. It's like knowing the rules and then breaking them!

Tips for Connecting Basic Strokes to Form Letters

Know your basics inside out: Mastering the basic strokes lays the foundation for further growth. When you have a strong foundation, it is easier to build on it and keep the progress going. Learn and understand the way the basic strokes are formed and practice them until you can rely on your muscle memory. You'll know when you have built your muscle memory with the basic strokes when you don't have to concentrate so hard on how to form them. This is akin to getting on a bicycle after years of not riding. Your muscle memory allows you to successfully ride one again without having to think about the mechanics of it all like a beginner. When you have built your muscle memory with the basic strokes, you will experience more success when it is time to connect them to form letters. As tempting as it is to dive

into words and phrases right now, by rushing ahead you will be met with frustration. Start small, start slow, and ensure you know your basics before moving on to connecting them.

Lift in between: Remember that brush pen lettering is not the same as cursive handwriting. In cursive handwriting, you rarely lift your pen off the paper. With brush pen lettering, you lift your pen after each stroke. You draw individual shapes (strokes) to form a letter. By lifting, you are forced to slow down, and when you slow down, your letterforms will appear cleaner. Make each stroke count.

Anticipate: Lifting between each stroke allows you to take a brief pause to visualize where and how the next stroke should be placed. Think about where you should place your tip so that when the stroke connects to the previously drawn stroke, there will be enough breathing space in between or not too much space that it doesn't connect at all.

Cursive handwriting. Start at the dot and keep moving until the letter is complete.

Lettering. Each letter requires two or more strokes and you lift between each one.

Step 1. Envision the oval and place the tip at the dot.

Step 3. Envision the exit stroke and place the tip at the dot.

Step 2. Envision the descending stem loop and place the side of the nib at the arrow (using full pressure).

Anticipate and visualize where the next stroke will be placed.

Guidelines for Practicing the Alphabet

Practice guide sheets are on page 108. On page 111 is a guide sheet with lines spaced 15 millimeters apart (i.e., the x-height equals 15 millimeters, which is set up to use with large-tipped brush pens). The sheet on page 109 has lines spaced 7 millimeters apart (an x-height of 7 millimeters) and is suitable for use with the small-tipped brush pens. Both sets come with or without slant lines. The slant lines are 55° (from the baseline) to help you keep the slant in your strokes consistent. Use tracing paper or other thin papers suggested in Chapter 1 and place it directly onto the guide sheets.

For each practice session, avoid going through the entire alphabet at once: Because we know that the basic strokes form the structure of all these letterforms, they can be grouped by the strokes that they share and practiced together. For instance, practice the lowercase a, i, u, and w together because they all utilize the underturn stroke. By the same token, if you want to focus on improving the oval, you can

group the letters a, d, g, and q. Whatever your focus is for the day, group the letters by the basic stroke that they share.

Fill a page or two to get a feel for it: Even if you are grouping letters together by the basic stroke that they share, fill a whole page with each letter.

Try tracing first until you get the hang of it and then try creating the letters on your own: It's like the training wheels on a bike. It's okay to go back to using tracing paper if you feel that your forms are shaky or that you need a reference for where your strokes connect.

For a sample guide of lowercase alphabet letters, see page 113. For a sample guide of uppercase letters, see page 117. In fact, this version of the uppercase alphabet is my go-to. It is relatively simple and, therefore, can be used as a base to build your own style. I would recommend spending most of your time mastering the basic strokes and, subsequently, the lowercase alphabet before tackling the uppercase alphabet. You can always come back to this section of the book when you are ready to learn the uppercase alphabet. At the beginning of my lettering journey, I practiced daily using only the lowercase alphabet for at least four months before I had the courage to learn the uppercase alphabet. When I was ready, I made a conscious effort to practice and diligently learned one letter a day for 26 days.

Further Practice—Letter Combinations

Time is limited, so let's make the best of it! First, you started with the basic strokes. Then, you used drills to practice single strokes or combinations of them. You have learned the letterforms and now you are ready for more connections. Each step in your practice gets more challenging, but if you start small, it is easier to gradually build up your skills.

The English alphabet is chock-full of patterns or repeating combinations of letters. That's why I believe that in order to use your time wisely, it makes sense to practice the letter combinations that are the most frequently used in writing. These are the combinations you will encounter the most. As you use them to focus your practice, you get better at making connections, and the combinations will already be familiar to you when you are ready to letter words and phrases that include them.

ch ch gn gn ng ng

ck ck kn kn nk nk

gh gh mb mb

Digraphs

ph ph th th chr chr

qu qu wh wh dge dge

sh sh wr wr tch tch

Digraphs Trigraphs

ae ae ea ea oo oo

ai ai ee ee ou ou

au au ei ei ue ue

ay ay ie ie ui ui

ay ay oa oa

oi oi

Vowel combinations

Digraphs and Trigraphs

Digraphs are combinations of two letters that make one sound, such as ch, ck, gh, gn, kn, mb, ng, nk, ph, qu, sh, th, wh, and wr. The photos show the stroke-by-stroke connection on one side and the result on the other.

Trigraphs are combinations of three letters that make one sound, as in chr, dge, and tch.

Vowel Combinations

The following vowel combinations occur most frequently: ae, ai, au, ay, ea, ee, ei, ie, oa, oi, oo, ou, ue, and ui. Note that two possible ways of connecting letter a to y are shown.

Moving onto Words

One of the hardest parts about learning how to letter is not moving onto words so quickly! With lettering, it's all about building a strong foundation and progressing in small steps so that you'll be more than ready when it's time to build words. So, I hope by now that you've spent some considerable time mastering those basic strokes, working those drills, familiarizing yourself with the letterforms, and practicing common letter combinations.

As a beginner, you are concentrating so hard on so many factors. Am I holding the pen correctly? How much pressure do I apply? When do I start to increase or decrease the amount of pressure? Which stroke is next? The last thing you want to do is think about which words to practice. To spend less time thinking of random words and more time on lettering, think of a theme and the words that would fit under that theme. For example, maybe you're a coffee lover like me, so words like cappuccino, latte, flat white, Americano, and espresso give me a great starting point. Or maybe it's colors, fruits, donut flavors, favorite TV shows, and so on. Whatever it is, a theme helps the words come naturally to your mind during practice.

Another starting point to practice can come from social media. Instagram is an excellent forum for all things lettering. Many artists, beginners and experienced alike, share their work on this visual platform, and some have even come up with monthly lettering challenges. These lettering challenges are usually based on a theme and are set up so that on each day of the month, there is a word or phrase you can letter out in your own style. Having the words set up for you each day is one less thing to think about, and that's a bonus in my book. This helped me out immensely when I first started learning, so I believe

it will help you, too. On top of that, following monthly challenges encouraged me to keep up with my practice daily.

Tips for Connecting Letters to Build Words

Keep the connection between letters consistent: When connecting letters to build words, you may find that there is something that doesn't look quite right. Looking carefully, some of the letters can appear too close together and others too far apart. The spacing between the letters can be inconsis-

The connecting strokes are about the same size, resulting in even spacing between the letters.

tent. To fix this, focus on the stroke that connects one letter to the next. It's the stroke that acts as both an exit stroke of one letter and the entrance stroke of the subsequent letter. Make sure that you make this stroke about the same size each time. It all comes back to building the muscle memory. When this stroke is about the same size each time, your letters will be spaced apart evenly.

Know when to adjust the connecting stroke: Depending on which letter you are connecting next, you may have to adjust the length of the connecting stroke slightly. Specifically, if you are connecting to an oval, this connecting stroke (i.e., the entrance/exit stroke) does not need to go all the way from the baseline to the waistline. Because you are connecting to a curved stroke, stop about two-thirds of the way to the waistline so that you allow for a cleaner connection. If you go all the way to the waistline, you will see the end of the

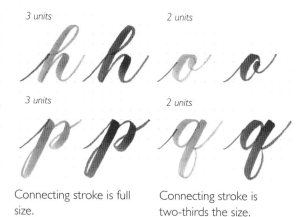

Connecting stroke is full size.

Connecting stroke is two-thirds the size.

stroke poking out or you may even compensate by drawing the oval too far to the left to cover the top end of the connecting stroke. If you are connecting to any other type of basic stroke, you can draw the complete entrance/exit stroke (i.e., go all the way to the waistline). The next stroke that connects to it should make an elegant connection.

Keep the weight of your strokes consistent: Another way to ensure that your words look great is by keeping all the thin strokes the same weight and all the thick strokes the same weight.

Downstrokes are different thicknesses

Some upstrokes are thin, others are thick

Downstrokes are the same thickness, upstrokes are the same thickness.

Sometimes it is glaringly obvious, other times it is quite subtle, but when some upstrokes are thinner than others, or downstrokes thicker than others, the lettering does not appear polished. Again, it all comes down to muscle memory (you saw that coming, right?). If needed, go back to the basic strokes and aim for consistency in size and weight.

Use the staircase method: When you first start practicing words, you might experience cramping in your hands due to not being used to applying different pressures over a longer period. To alleviate that, build stamina, and make practice more fun, use the staircase method for practicing words. You start off with the first letter of the word. Then start a new line with the first and second letter of the word. On the third line, do the first, second, and third letter of the word. Repeat this until you finish the whole word. Aim to have each line of letters look the same as the previous. In the end, you will have created a staircase effect and reinforced the muscle memory in your letterforms.

See page 121 for practice templates of common words that you may be using for upcoming projects, such as your own greeting card, letter, or sign. Feel free to trace over them or practice them on your own. The strokes are shown in alternating shades of gray so that you can see how they connect.

CHAPTER 4
Practice Makes Progress

You can have all the right tools and the best of intentions, but at the end of the day, practice is what will move you forward. Practicing with focus and intention is how you can make best of the time you have to reach your lettering goals. It's also important to understand that progress may not be as linear as you hope it to be and that is perfectly fine, too. You will experience moments and days when you feel like you have made a lot of gains and others when you have made very little. It's how you approach those dips in progress that will determine the path of your learning.

Here are some tips that will help you to keep moving forward.

Find Quality Practice Time

Quality versus quantity: Practice with intent and make it a mission to keep your strokes or letterforms looking the same each time. For each practice session, focus on one issue you want to improve on. Spending a lot of time just filling pages will not necessarily help you to improve. It's better to fill a half page of deliberate and focused practice rather than a couple of sheets of mindless work.

Be consistent: Practicing on a consistent basis is more beneficial than practicing in large chunks of time with long breaks in between. Even devoting 15 minutes of focused practice four times a week is better than practicing for one hour a week in one sitting. Try setting a timer. There is something about knowing you have a limited time that pushes you to use it more effectively. I tend to zone in when I have a timer going and in the end I realize that practice does not have to take a large part of my day.

Start saying no: If you're serious about making progress, say no to other things in your life to make room for practice. This might mean choosing brush lettering over some of your other favorite pastimes or spending less time doing them.

Have a Designated Workspace and Set the Mood

Choose a space in your home where you have a flat surface, good lighting, and a comfortable seat. Ensure that your tools and materials are within easy reach. Luckily, the beauty of doing lettering with brush pens means that you don't have to fiddle with ink and separate nibs and holders. Setting up and cleaning up will take just a sliver of your time.

Minimize distractions so that even if you can only afford 15 minutes at a time, every minute will count. Set your cellphone to Airplane Mode and let the people you live with know that you are not to be disturbed.

To make practice more enjoyable, set the mood of the space you are in. For me that means playing music in the background, and having a cup of coffee and maybe a little bowl of snacks on the side. For you it might mean playing your favorite TV show in the background and lighting a scented candle. Whatever it is that you need to do, just do something that will make practice time an enjoyable time for you.

Sometimes there will be days when you just don't feel like practicing. Rather than forcing yourself, just skip the practice and revisit when you feel refreshed. You'll make better use of your time when you look forward to practicing.

Slow Down

Even if you thought you had slowed down, you may not have slowed down enough. Take control of your brush pen and, literally, move slowly as you create one stroke at a time. If you're moving slowly enough, you should be able to watch how your tip reacts to the pressure you apply. Slowing down leads to cleaner-looking strokes. When you speed up, your strokes can look uneven and heavy in areas where you don't want them to. Slowing down will also help you when connecting the basic strokes. Take your time to place the tip of your brush pen at the right spot when connecting one stroke to another.

If you are finding frustration in lettering whole words, scale back and focus on individual letters. By the same token, if you're experiencing frustration in individual letters, focus on individual strokes. If it is certain letterforms that you are having difficulty with, such as all the ones requiring an oval, then take a step back and give some undivided attention to the oval and call it a day.

Evaluate Along the Way

Whether you are focusing on the basic strokes, connections, or letterforms, take a pause after filling a half page or so and reflect on how you are doing. You may see a variety of issues to work on, such as stroke consistency, connections, and inconsistent slant, to name a few. Critique your work and jot down comments directly onto the paper, making note of what needs to be worked on. This will help you decide what to focus on going forward.

Choose One Focus for the Day

This tip goes hand in hand with evaluating your work. Look back on the comments you wrote on your practice pages and choose just one to focus on for today's practice session. Write your goal at the top of the paper to prepare your mind and to keep it as a record for future reflection. Now, move on with practice, focusing on that single issue. Complete a line or two of practice, pause, and look back. Don't worry about any other issues you see; just keep focusing on the one you decided to work on for today. Keep going and, once you have filled a page, again look back and jot down some comments on how you are doing. Look for improvements, too! You can repeat this process for other issues you would like to work on (but not necessarily in one day). Just remember that focusing on one issue at a time with consistent reflection makes for purposeful practice.

Practice with Guidelines

Whether you are just beginning or you've got a lot of experience under your belt, there is absolutely no shame in using guidelines. However, they are especially important at the start of your lettering journey. Guidelines will keep your strokes and letterforms consistent in size (and slant). Because you are building your muscle memory, you want to make sure that all that hard work at the onset goes into making your letterforms looking consistent. Be sure to touch the lines and not get lazy about it—the guidelines are there for a reason!

I highly suggest using paper like Rhodia that is already lined, dotted, or gridded for your convenience (see Chapter 1). Having the guidelines there saves time, which means more time for actual practice. If you have blank paper (such as tracing paper, marker paper, or laser printer paper), place a lined sheet underneath. If the guidelines are still difficult to see, then place both sheets over a light pad (see Creating Dynamic Layouts on page 77). The light pad shines light through the sheets so that the guidelines are made visible. The other alternative is to draw guidelines in yourself.

Use Pencil to Build Muscle Memory

A great way to build muscle memory without having to deal with a flexible tip is by using a pencil instead. You can still study and practice the formation of a stroke or letterform and build your muscle memory. Notice when to apply pressure, where to lift, and where the strokes connect in relation to each other and the guidelines.

Using pencil also saves the precious ink in your brush pens!

Explore a New Brush Pen

There is a variety of brush pens great for beginners (see Chapter 1), and each has its own personality. Although all are recommended for beginners, because they are slightly different from each other you may find that you prefer one over another. Some have large tips and others have small ones. Some tips are more flexible than others and therefore a little harder to control. Maybe the barrel of the pen just sits well in your hand or you just like the way it feels as the tip glides across the paper. If you have dedicated some time to one brush pen, maybe this is the time to try a new one. After exploring a few options, you will find one that will become your favorite.

If you are normally heavy-handed, try a brush pen with a slightly stiffer tip. Practicing with a brush pen that may be too flexible for your heavy hand will be harder to control at the beginning stages of your learning. (You'll have more success with this brush pen after gaining some experience.) For example, choose the Sakura Pigma Brush Pen over the Tombow Dual Brush Pen because it is a tad stiffer.

Large-tipped brush pens require you to draw letters on a large scale compared to that of your regular handwriting. It takes some time to get used to writing relatively large. Try small-tipped brush pens instead if you are having difficulty. You can draw the letters on a smaller scale and the pen itself may be easier to handle.

Strive for Progress, Not Perfection

Striving for perfection rather than progress may stunt your lettering growth. You'll get frustrated easily and may even consider giving up. Anything worth doing will take time and effort on your part, so give yourself a break, take a deep breath, and move on. One thing I keep in mind to stay motivated is that every step I take, no matter how small, is still one step closer to my goal. The slight imperfections that you see are what make your lettering charming!

Trust in the Process

Track your progress by recording the date on your practice pages and looking back at them from time to time. You may not see progress from day to day, but you will over several weeks if you are practicing consistently and purposefully. You will be amazed at what you can achieve! Sometimes we can be too critical of ourselves. Don't just focus on the issues you need to work on—celebrate the little victories, too!

A fun way of keeping track of your progress is by lettering a pangram such as "the quick brown fox jumped over the lazy moon," and dating it. Repeat this every few weeks or once a month and compare the work with what was done before. Again, make note of and record what you are doing well and look for areas that need improvement.

July 2015

August 2015

May 2017

CHAPTER 5

Embellishing Your Lettering

One thing I absolutely love about lettering is that the possibilities of injecting it with personality are endless. I am constantly learning about ways I can change up my lettering or kick it up a notch to keep things interesting, not just for me, but for my audience. Whether it's adding dimension, decorative elements, or blending colors, taking that extra step can make your lettering pop. These techniques are perfect for expanding your repertoire of quick and easy ways to take your lettering to the next level.

The following tutorials are meant to give you a starting point for dressing up your letters. You can keep working on your current script and just add on with the ideas laid out here. They may even inspire you to come up with your own way to add that special touch!

Adding Depth

Lettering is beautiful on its own, but giving it some depth can make it stand out more. Adding highlights or shadows, or both, gives your lettering an eye-catching look. To determine where to place highlights and shadows, you must decide where your light source is. The location of your light source affects the placement of all the highlights and shadows.

Highlights

To add highlights, use white to mimic light bouncing off the letters. A gel pen like the Uni-ball Signo Broad gel pen in white works perfectly for this technique.

1. Start by lettering out the word "love."

2. Decide the location of your light source. Imagine light emitting from your source and hitting your lettering. If you decide that the light is coming from directly on top of the lettering, add highlights to the middle of the downstroke as if the surface is convex. If the light source is from the top left, add highlights on the left side of the downstrokes because that is the closest part to the light source. If the light source is on the top right, add highlights on the right side of the downstrokes. Use a line and dot combination to mimic highlights and follow the natural contour of the strokes. Already, some life is being added to these letters!

Light coming from directly above

3. If necessary, go back and trace over each of the highlighted parts after the first layer of gel ink has dried. Depending on the paper, the ink may have become absorbed, making it look translucent. Adding a second or third layer will make the highlights look opaque.

Light coming from the top left

Light coming from the top right

Shadows

Drop Shadows

Now, let's take the same word "love" and add drop shadows. You will need a gray brush pen to do just the trick. Just be forewarned that there are many shades of gray: light, dark, warm-toned, and cool-toned. You may have to experiment with the ones you have and see what looks best to your eye. Sometimes it depends on the main color you choose for the lettering. Certain grays look better with certain colors.

Just as with adding highlights, the location of your light source determines where you draw the shadows. If it helps, place an object on your table and imagine it to be the source of light.

1. Use the same lettering with the highlights added to the left side of the downstrokes. Remember that your light is coming from the top left. Take your brush pen and run it along the right side of all the downstrokes to create shadows. Since downstrokes are thick, their corresponding shadows should also be thick.

Downstroke shadows for light coming from the top left

2. Since the light source is either on the top left or right, the shadows for all the upstrokes should be placed underneath. The weight of the shadows is determined by the weight of the strokes, so these shadows should be thin. With light pressure, run the brush pen underneath these strokes.

Upstroke shadows for light coming from the top left

Similarly, the lettering with the highlights added to the right side of the downstrokes has the light source located on the top right. So, draw the shadows to the left of all the downstrokes and underneath all the thin strokes.

Notice how much depth the lettering has with some added lines and strokes! This is a simple but effective way of enhancing your letters.

Shadowing for light coming from top right

You don't always have to use gray to add shadows. You can also use two different tones of the same color or any color combination you love—the lighter one for the lettering, and the darker one for the shadowing or vice versa.

Shadowing using two different tones

Shadow Lines

Another way to add shadows is to draw lines.

1. Begin by lettering the word "dream."

2. Decide on the location of your light source. For this example, let's place the light source on the top left, which means that the shadows will be placed to the right and underneath all the letters. Use a gray brush pen or any bullet tip marker (it may be easier!) and add lines by following the natural contour of each letter. Leave a little space between the letters and the shadow lines.

Shadow lines for light coming from the top left

Stippling *believe*

When stippling, you are adding numerous small dots or specks to your letters. This works best with markers that have a bullet nib. The nib is stiff and creates dots (or lines) of one size. If you have the Tombow Dual Brush Pens, the other end is fixed with a bullet nib in the same color as the brush tip. Otherwise, use any other bullet nib marker that you have at your disposal.

1. Letter the word "believe" in one color.

2. Choose a darker color so that the dots will clearly appear on top of the first color. To stipple, start adding dots at the top of the downstrokes. Concentrate most of the dots at the very top, and as you move down, decrease the concentration of dots. You can go as far as you'd like on the downstrokes.

Tip: If you decide to stipple from the bottom of the downstrokes, then concentrate most of the dots at the very bottom, and as you move up, decrease the concentration of dots.

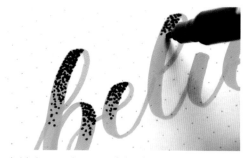

Add dots at the top of the downstrokes, decreasing the density as you move down the stroke.

Outlining *outline*

This super-simple step can easily make your lettering pop. Outline your lettering by following the natural shape of your strokes. Try not to leave any white space between the outline and your lettering for the cleanest look. If there are any white spaces, go back and color them in.

Doodles *starry night*

Adding doodles is another fun and casual way to dress up your letters. Using simple lines and shapes can easily add pizzazz and even complement the meaning of the words they appear on!

1. Choose a bold or dark color. Doodles will stand out better when there is enough contrast. Letter the word or phrase in this color.

2. Decide which doodles you will add. The same doodles can be applied to the whole word, or a combination of them. Use a gel pen such as the Uni-ball Signo Broad or Sharpie paint pen (with an extra-fine point) in white, which will allow the doodles to stand out against your beautiful lettering. Another color that is great for doodling is gold because it gives just enough shimmer to brighten up your lettering.

3. If you use a white pen, trace over the doodles to increase the contrast. Some colors may absorb the white ink from a gel or paint pen and cause the doodles to look dull.

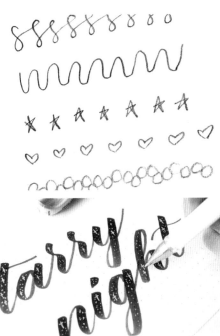

Trace over the doodles with a white pen to increase contrast.

Layering *sunshine*

Layering involves using two or more colors on top of each other. The transition from one color to the next is sudden, not gradual. You can choose lighter and darker shades of the same color or choose any other combination as long as one color is lighter than the other.

1. Choose a yellow brush pen and letter the word "sunshine." This acts as your first layer.

2. Take a scrap piece of paper and cover the area of the lettering you want to keep, in this case, roughly the top third of the yellow lettering. Use a darker color, such as orange, to trace over the parts that are exposed.

Trace part of the yellow lettering with a darker color.

3. (Optional): Again, take the scrap piece of paper to cover the first layer and parts of the second layer. Trace over the exposed parts of the second layer using an even darker color, such as red. In this example, you can see that the colors chosen emphasize the meaning of the word.

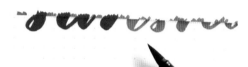

To create a third color layer, cover part of both the first and second layer with an even darker color.

Tip: Whichever color combination you choose, test it out by layering the colors over each other before lettering out the whole word or phrase. Ensure that any layer of color added is opaque and does not allow the layer of color underneath to show through.

Ombré Effect

Creating an ombré effect is like layering, except the colors graduate from dark to light. It takes a bit more effort than layering, but the results are well worth it. There are a few ways you can achieve an ombré effect.

Ombré Method 1

The first way involves using one brush pen. Light to medium colors work best and the result is quite subtle.

1. Letter the word "smoothie."

2. Add a second layer to the top half of the downstrokes. In the section where the transition needs to be gradual, feather the strokes in a quick, downward motion. It's fine to go back and touch up where necessary.

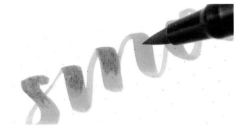

Choose a darker shade and add a second layer of color to the top half of the downstrokes.

Ombré Method 2

The second way requires two or more shades of the same color (i.e., a light and dark version preferably not more than a couple of shades apart).

1. Letter the word "fancy" with the lighter color first.

2. Go back with the darker color and use the same technique described in Method 1, where you start at the top of the downstrokes and make quick, feathery strokes in a downward motion, especially in the section where the transition should be gradual.

3. Use the lighter color again and go over the section where the transition should be gradual. The brush pen will pull down the darker color so that it appears like it is fading into the lighter color.

Tip: Follow steps 2 and 3 letter by letter. It is easier to blend colors when the ink is still wet. If you apply the darker color to all the letters then go back with the lighter color to blend, you will find that it is harder to create a gradual transition.

Use the darker shade and add a second layer of color to the top half of the downstrokes.

Use the light color again and go over the transition area to create a smoother fade.

Ombré Method 3 *waterfall*

If you find that Method 1 and 2 add too much of the darker color or make the transition from dark to light difficult to achieve, you can gain better control with just a couple more tools: a blender pen and a nonporous surface. A blender pen is a colorless, water-based brush pen that is used to soften or blend colors together, creating a watercolor-type effect. A few companies make this pen, but one that comes to mind is the Tombow Dual Brush Pen in N00. Tombow also makes a Blending Palette, which has a unique surface that allows you to blend and mix colors. You can also use a plastic sandwich bag, an acrylic block (often used for stamping in various crafting jobs), or even the plastic packaging your brush pens might come in! As long as the surface is nonporous and can be easily cleaned afterward, it can be used for blending colors.

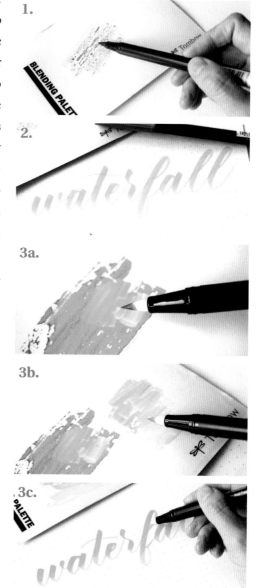

1.

2.

3a.

3b.

3c.

1. Using your blending palette or other nonporous surface, lay down the ink of the darker color. Make sure to angle the pen on its side while swiping back and forth to protect the tip.

2. Using the lighter color, letter the word "waterfall."

3. Now use the blender pen to pick up the ink left on the nonporous surface. Make sure to rotate the brush tip as you pick up the darker ink so that the whole tip is covered. Now, rub some of the extra ink off on the nonporous surface. This will keep you from adding too much ink in the beginning. The tip of the blender pen will become stained, but do not worry because as you keep using the blender pen, the color will wear off and the tip will go back to its original color. The Tombow Dual Brush Pens are self-cleaning in this respect. Other water-based brush pens like the Sakura Koi Coloring Brush Pens can be used in this way, too. Think of the brush pen you used to pick up the darker color as your paintbrush. Brush the

darker color onto the downstrokes of the lettering using a light and feathery motion. Apply as many coats as you like to increase the intensity.

Ombré Method 4 *waterfall*

If you don't have a nonporous surface available, you can take the blender pen and brush the tip of the blender pen directly onto the tip of the darker colored pen to get some color. You can then use the blender pen to apply the darker color onto your lettering and keep repeating this until you get the desired result.

Blender pen

Now if you'd like to have the transition from dark to light coming from the bottom, turn your paper upside down and follow the same steps. Turning your lettering upside down allows you to use a downward motion, pulling the brush toward you, to add the darker color. It's much easier than keeping your lettering right side up and using an upward motion instead!

You may find that as you add more layers of color, the paper starts to shred. As the paper absorbs more ink, it becomes soft and will start to break down with friction. Just be aware of this and continue to use a light hand. If any of the paper fibers stick to the nib of the brush pen, wipe them off before continuing so that the fibers do not add unnecessary lines to your work. If the fibers stick to the lettering itself, wait until the ink dries before rubbing them off.

Turn the paper upside down to create the dark-to-light transition from the bottom up.

Blending

Blending can be achieved with the same technique used to create an ombré effect, except the change from one color to the next can occur in different ways.

Blending from One Color to Another Across a Phrase

1. Choose two colors. Take the lighter color and saturate its tip with the darker color via the Blending Palette (or other nonporous surface as described in Ombré Effect 3, page 58) or by brushing the tip of the darker color directly onto the tip of the lighter colored pen. In this case, make sure the whole tip is covered with the darker color.

2. When you start lettering the word, the darker color should appear first. As you keep lettering, the darker color will wear off and, eventually, the lighter color will appear. If the darker color wears off too fast, you can always go back and add more to the tip of the lighter colored pen.

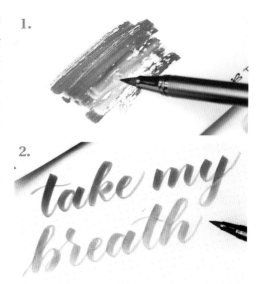

Rainbow Blending *rainbow*

Rainbow blending involves two to three colors that appear blended within each stroke.

1. Choose two or three colors. With the lightest color in one hand, brush the ink of the darker color directly onto the very tip of the lighter colored brush pen, leaving the rest of the tip untouched. What you should see now is two stripes of color on the tip. If you have a third color, take that one and brush the ink directly onto the tip of the lightest color brush pen next to the color you just applied, making sure to leave the section farthest away from the tip untouched. You should have three stripes, one of each color.

2. Letter the word "rainbow." You should expect to see all two (or three) colors showing in each stroke you create. If you don't, it may mean that the different-colored sections of your brush tip may be too wide. To get rid of all the ink and start over, you can take a scrap piece of paper and wipe off the darker ink(s) until the tip goes

back to its original color. Now, try again but make the different-colored sections thinner. You can press down on the tip beforehand and see how much of its side touches the paper. Then you will know how far you can go up the tip.

As you letter, the darker colors will wear off. Expect to reapply the darker color to the tip of the lighter color as you complete the word.

Tip: Always complete a stroke before stopping to reapply darker ink to the tip of your brush pen.

Combining Ways to Embellish Your Lettering

Now that you have a few ideas of how to dress up your lettering, get creative and combine a couple of the methods to create a stand-out look!

Another popular way to dress up your lettering is to make it appear like a galaxy. This involves moody, dark colors with a pop of something bright, like pink or lime green. The bright color would act as the base and over the top, you could blend in colors like black and dark blue. For the starry effect, you need a white gel pen or paint pen. Add different-sized stars—smaller ones by sporadically adding dots and a few larger ones by simply making crosses.

Developing Your Own Style

Now that you have learned a basic script style it is natural to feel that you want to make it your own. But you may have no idea where to begin. You also may have already noticed that despite how much practice you have put in, your letters look a little different from the ones that you've been shown so far, and that is completely fine. Remember that you are lettering by hand. The fabulous part about this is that although you can mimic certain lettering styles, there will always be nuances that set apart your lettering from anyone else's, and this is a good place to start. Embrace the individuality of the art created by your own hand.

Finding your own style comes from a lot of practice and experimentation so it goes without saying that it can take a relatively long time to develop a look that you feel represents you. And even when you do, you can expect your style to continually evolve as you experiment and continue to learn. In addition, observing and admiring other artists' lettering work will help you develop an eye for what appeals to you and will help you find the aesthetic that represents you and your personality.

The following tips will give you a starting point for playing with your lettering. They are one-step changes to the basic script style you have been learning through this book. The idea is that by implementing these tips, you will find what appeals to you and incorporate what you like.

The lettering that has been shown up to this point has been created on a straight line with the guidelines dictating the proportions of the letters. The slant has also been at the same angle. By making one change or by combining several, you can alter the look of your lettering in a pinch. You've learned the "rules" of basic lettering, now it's time to break them and discover your style in the process!

Changing the Slant

Let's begin by changing just the slant of your lettering. The alphabet shown in this book has been lettered at a slant of approximately 55° (from the baseline).

Downstrokes are drawn at approximately 55° from the baseline.

Now, let's completely change that and try lettering straight up and down! If needed, draw in pencil lines that are perpendicular to the baseline about an inch apart, or better yet, use paper that already has the lines drawn in, like the gridded Rhodia paper (see Chapter 1). When drawing letters straight up and down, it will be helpful to keep your paper perpendicular to your body.

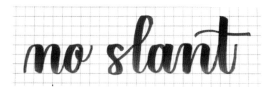

Downstrokes are perpendicular to the baseline.

This time, let's go to the other extreme and draw letters at an angle less than 55°, say 45°. It's only a difference of 10° but it will be noticeable. You will be better off drawing these slant lines on your paper. Use a protractor to be exact or estimate the angle and draw the lines equidistant from each other. When lettering, it may be necessary to rotate your paper more than normal to achieve this new angle.

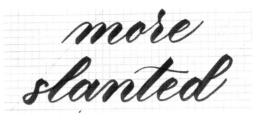

Downstrokes are drawn at 45° from the baseline.

Changing the Spacing

If you keep the original guidelines and the slant at 55°, you can still make a change by increasing or decreasing the space between the letters.

Widening the space between letters

To widen the space between your letters, extend the connecting stroke farther out. Don't be shy about the spacing; in fact, by extending it out purposely, the final look will appear more polished.

Narrowing the space between letters

Now, focus on decreasing the space between your letters to achieve a tighter look.

Change the Size of the Loops

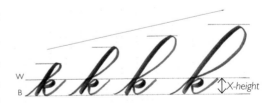

The ascending and descending stem loops can be exaggerated as well to give off a whimsical vibe.

Start with moving the ascender line upward so that the distance between it and the waistline is larger than the x-height. Draw letters with ascending stem loops, like the lowercase b, d, k, and l with this new guideline. Make the loop larger by bringing the pen farther out to the right. Experiment and do it again, except go out even farther. Now, move the ascender line upward even more and do the same.

Increasing space between ascender and waistline

The idea is the same for letters with descending stem loops. Lower the descender line or increase the distance between it and the baseline so that it is bigger than the x-height. Experiment with the size of the loops as you did with the ascender stem loops and then try lowering the descender line even more.

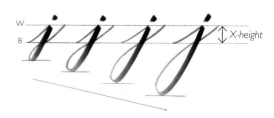

Increasing space between baseline and descender

Regardless of how large you make the loops, keep them consistent in size when lettering a word or phrase. Consistency is the key to making your lettering appear polished rather than haphazardly put together.

Changing the Guidelines

It's time to play with the guidelines.

First, increase the x-height on all your letters by making the distance between the baseline and the waistline larger than the distance between the waistline and the ascender and the baseline and the descender. Draw these lines in pencil on your paper so that it's easier to focus on how far to go with your strokes.

Increased x-height with standard spacing between ascender/waistline and baseline/descender

Next, letter in a word using the new guidelines. The result is a more playful and carefree look.

Now, try keeping the x-height the same but increasing the distance between the waistline and the ascender and the distance between the baseline and the descender to double the x-height.

Use the new guidelines and letter in a word. Notice that you gain a completely different look than when you changed just the x-height. The lettering appears more elegant.

Standard x-height with elongated space between ascender/waistline and baseline/descender

Changing the Baseline

Up until now, you have been lettering straight across the paper where all your letters sit on the baseline and ascend or descend the same distance upward or downward, respectively. While this look has its place (it's simple and clean), you may be wondering how you can achieve that "bouncy" lettering that is everywhere nowadays on prints, cards, invitations, and more. The letters appear to dance, bouncing up and down in a graceful way. The look is fresh and modern and certainly achievable.

To achieve this modern, bouncy style, you must understand and identify where the center of gravity is for each letter. The center of gravity is where the bulk of the letter's weight is located. If the center of gravity for each letter lies at the same level, regardless of high or low other strokes extend, then the final look will appear polished and pleasing to the eye.

Look at the two samples below. Which one is more pleasing to the eye?

Now, let's take a closer look to see how they differ.

With the first sample, notice that although the strokes of each letter have been extended, especially the connecting strokes, the final look is balanced. This is because the center of gravity of each letter falls at the same level.

In the second sample, the center of gravity does not lay at the same level throughout the word. It is quite scattered. This makes it look as though the letters were drawn haphazardly. Although legible, there is something "off" about this final look.

Center of gravity at the same level

Center of gravity is scattered

Here is another set of samples. Compare the two by looking for the center of gravity of each letter and checking to see if they lie on the same level. Decide for yourself which one looks balanced and which one does not.

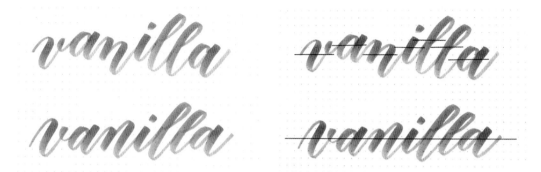

If you guessed that the word on the bottom is balanced, you are correct. The center of gravity for every single letter lies at the same level. The letters in the word at the top seem to have a mind of their own. The center of gravity for one letter is at a different level than the letter next to it, and so on.

Another way to look at how to achieve this bouncy lettering is by keeping the x-height the same for each letter but breaking through the baseline and waistline with some of the strokes.

Notice in this example that the overturns extend beyond the waistline and the connecting strokes extend below the baseline.

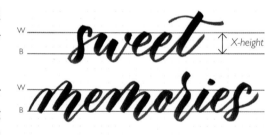

How do you know which letters to alter? Not every letter needs to be altered to achieve a bouncy look. Changing every other letter or so will certainly do the trick. This will allow for some breathing room between the letters and the look will be better balanced. Remember, as long as the x-height of the letters stay relatively contained between the baseline and the waistline, then extending just beyond these two lines, here and there, will keep the word as a whole balanced.

Let's look at the words "sweet memories" again and dissect it further. Notice that in the word "sweet," the letter s extends beyond the waistline and the baseline, then the connecting strokes of the w and the second e extend beyond the baseline. The altered strokes are spaced apart. The top part of the t and its crossbar balances out the top of the word to give a fullness to the whole word.

In the word "memories," about every other letter is altered. In the latter half of the word, instead of the letter e being altered, the final letter s is instead, to balance out the first letter of the word, which is altered as well. The first and last letters appear to anchor the whole word in place.

At first, it may seem like there is way too much to think about in order to achieve bouncy, modern lettering. If you don't get it right away, don't give up. Try altering the same word in different ways. Like everything else, it will take some time and practice. Don't forget to have fun along the way!

Adding Flourishes

Flourishes are curved lines and swirls based on the structure of an oval that serve as decorative elements to any lettering design. They can be added directly to letters or they can be placed just outside of the letters to add balance, fill negative space, and elegance to an overall look. Flourishes are often associated with fancy or formal calligraphy but have their place in simple or modern lettering as well. They add just the right touch of whimsy and flair.

Flourishing was a skill that I added to my repertoire much later (and am still working on), long after I learned the letterforms. It certainly takes a lot of practice, too, so don't be too hard on yourself when you don't get it right away. Focus more on becoming familiar with the movements rather than trying to get the look perfectly executed.

There are the major tips I have when it comes to flourishing:

Use whole-arm movement. When you use your whole arm to make movements, rotating only at the shoulder (see Chapter 1), your brush pen will glide on the paper, thus giving way to smoother lines. Transitioning from the thick part of a letter to a thin flourish, and vice versa, will be easier, too. Using your whole arm will allow you to move in any direction, over a larger area of space.

Use thin lines. Stylistically, you can choose to add flourishes with thick and thin parts but for someone just starting out, focus on just using thin lines. Therefore, just use the tip of your brush pen and apply light pressure to make flourishes.

Build muscle memory. Flourishing doesn't just come out of nowhere. Just like with the basic strokes and letterforms, you can practice basic shapes of flourishing to build muscle memory. Then, when you add them to letters, it'll feel more natural and you'll fumble less.

Move slowly. Trouble follows when we think that drawing smooth lines and curves means that one must move quickly. It's just the opposite. Maintain a slow and steady speed to stay in control.

Sketch first. Use a pencil to sketch the flourishes first. That way you can erase and try different shapes to see what looks best before using a brush pen. This also helps when you are not sure how much room you have to add a flourish. So, lettering a word or phrase in pencil first will allow you to see where the opportunities are and ensure that when you finally use a brush pen, there will be space for flourishing.

Sketch the lettering in pencil so you can plan where any flourishes go.

Draw in the air. Jumpstart your muscle memory by drawing the flourish in the air before committing and putting your brush pen to the paper.

Allow the flourish to breathe. Try not to squish a flourish into a small space. If the space does not allow for it, choose something simpler. Make sure that the lines flow and that the loops are wide enough to allow air to "flow through it." Otherwise, they will look deflated or flat.

Basic Flourishing Shapes

To give you a starting point, here are some basic flourishes I use repeatedly that I'm sure you'll grow to love as well.

As with the basic strokes and letterforms, building your muscle memory with flourishing is so important. Set aside your brush pens for the moment and start with a pencil instead. A pencil will allow you to focus on the movements alone. You won't have to worry about maintaining a light hand while you are trying to remember which way to curve. As you practice these basic flour-

ishes, remember to use your whole arm—it will allow for a greater range of motion and your lines will turn out smoother. Another perk of using a pencil means that you can just erase your mistakes and try again! Save your brush tips while you can.

Once you build the muscle memory so that the movements feel more natural to you, try the basic flourishes with a brush pen. Focus on keeping a light hand to draw flourishes with thin lines. Aim for

consistency in the smoothness of your lines and look for gently flowing curves. A considerable amount of time can be spent on flourishing alone, so don't fret if you feel like you can use more practice.

Applying Flourishes to Letters

With all that practice put in to building muscle memory, you are ready to apply your new skills and take your lettering to the next level! Most of the flourishes that you add to your letters require transitions from thick to thin strokes, and vice versa, which can only be done with the flexible tip of a brush pen. Your ability to control the pressure on the tip will be crucial to adding a flourish that complements your lettering rather than competing with it.

Flourishes on Letters with Descenders

Lowercase letters with descenders like g, j, y, and z provide a natural opportunity to add flourishing. Even letters like p and q can have flourishes, too.

The same flourishes can be applied to letters j, y, and z, and even letters like p and q.

The flourish would come directly off the descender, which means that there is a transition from the thick downstroke of the letter to a thin stroke, which is the flourish itself. Normally, the letter would be finished off with a descending stem loop that closes in on itself, but with flourishing you create a different shape at the bottom of the letter. Make sure that you keep light pressure on the flourish itself so that although the flourish becomes a part of the letter, you can still distinguish between the two.

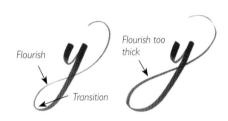

Correct transition (left) and incorrect transition (right)

One of the hardest parts about adding a flourish to letters with descenders is transitioning between the thick part of the letter to the thin part of the flourish at the right point so that there is a distinction between where the letter ends and where the flourish begins. Because you are starting off with full pressure to draw the downstroke, it is easy to go a little too far with the heavy pressure before transitioning into the

Space out the next letter as if there was a connecting stroke.

The letter that follows a flourish does not connect

flourish. If the bottom of your letter appears heavy or the transition from thick to thin is lacking, try lightening up on the pressure sooner.

For now, you may be practicing flourishing on individual letters and that's the perfect next step to flourishing with ease. When you are ready to incorporate a flourish within a word, keep in mind that the letter that follows a flourish will not be attached by a connecting stroke. Just space out the next letter as if you do have a connecting stroke in between.

Flourishes on Letters with Ascenders

Letters with ascenders also take to flourishing like those with descenders. For lowercase letters like b, d, h, and k, you would normally use an ascending stem loop. Instead of having a closed loop, you are opening that loop and turning it into a flourish, thus creating a different shape at the top of the letter. Therefore, you will start off with light pressure

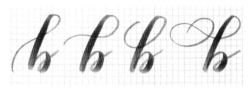

Sample flourishes for letters with ascenders

then transition into heavy pressure to complete the stem of the letter. The same types of flourishes can be also applied to letters like f and l.

When you are ready to incorporate a flourish within a word, the letter with the flourish can still be connected to the letters that appear before and after it.

Flourishing the Cross Stroke

The horizontal stroke that crosses the lowercase t is called the cross stroke. Just by adding curves to this stroke, the personality of this letter, and the word that it is a part of, changes in an instant.

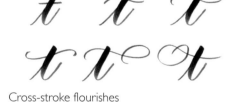

Cross-stroke flourishes

Flourishing at the Beginning and Ends of Words

Consider letters with ascending stem loops that appear at the beginning of a word. Instead of starting with an entrance stroke, you can go straight into a flourish. Even a simple curved line can elevate the look of your lettering. Experiment with placing this flourish at different heights of the letter. On the letters that appear at the ends of words, you can also add a simple flourish instead of finishing with an exit stroke.

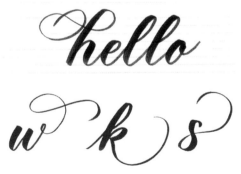

Samples of flourishes you can use at the end of words

Flourishing Other Letters

It may not be as obvious but you can also add flourishing to the bottom of letters, like m, n, and r. Again, the transition from the thick downstroke to the thin stroke of the flourishing must be such that there is a distinction between where the letter ends and where the flourish begins. A thin flourish complements the letter, so take care to keep the transition from the thick downstroke to the thin flourish clear. The thick part of the downstroke should not appear like it was "dragged out" into the flourish.

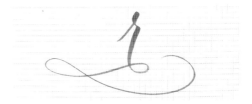

Bottom flourish on the letter r

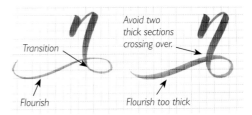

Correct (left) and incorrect transition (right)

Combining the Cross Stroke with the Flourish of Another Letter

The cross stroke of the lowercase t can be combined with the flourish at the top of another letter. Words that contain letter combinations, such as td, tf, th, and tk, allow for that opportunity.

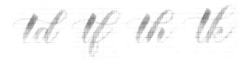

You can also find opportunities to combine the flourish at the bottom of letters with the cross stroke of the letter t.

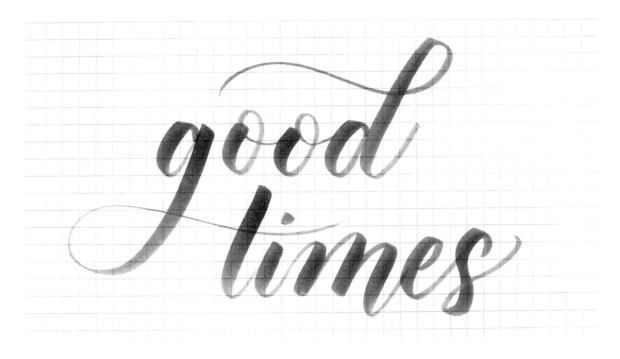

Combining Changes to Your Script

Although there are many ways to manipulate your basic script, such as by changing the slant, size of loops, or guidelines altogether, combining more than one of these ways is how you'll make the most impact to your style. Just have fun and stay open-minded about the process because developing your own style requires a lot of experimentation. Over time, trust that you will develop an aesthetic that reflects your personal style and embrace the idea that because it is created by your own hand, your style will be like no one else's.

The following examples show words lettered in a basic script and how a combination of stylistic changes made to the same words changes up the look:

The basic stroke (top) altered with wider spacing and large loops (bottom)

Bouncy lettering and flourishing

No slant and large x-height

Large loops and flourishing

Going Beyond a Script Style

You've got a handle on the script style so far. You've even ventured onto embellishing your letters and tweaking guidelines and slants to start developing your own style of script. To further expand your repertoire of lettering skills, you'll also need to experiment with other styles of lettering that exist: the sans serif and the serif styles. When you become familiarized with all three types, you allow yourself the opportunity to mix and match your letters to create thoughtful, dynamic designs that evoke certain feelings and enhance the message inherent in the words.

Out of all three, the script style resembles handwriting the most in that the (lowercase) letters are joined together. The flow from one letter to another brings about a natural gracefulness to this style.

The serif style lettering is characterized by the serifs, or the small strokes, that appear at the ends of the strokes.

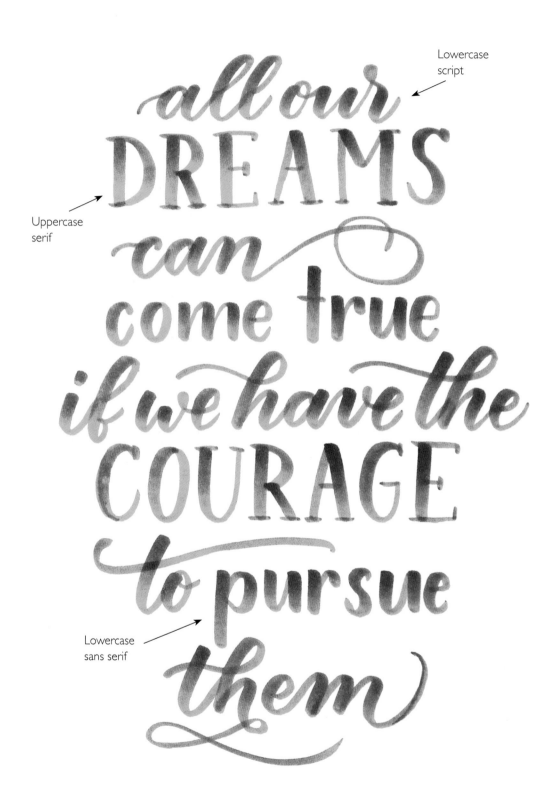

all our
DREAMS
can
come true
if we have the
COURAGE
to pursue
them

Lowercase
script

Uppercase
serif

Lowercase
sans serif

Sans serif style lettering does not have serifs. The word "sans" means "without" in French. This style of lettering appears clean and modern, while the serif style can be more traditional in comparison.

ABCDEF abcdefg
GHIJKLM hijklmn
NOPQRST opqrst
UVWXYZ uvwxyz

Becoming familiar with and having the ability to combine all three types will help you develop your own style and become a versatile lettering artist.

Overall Cohesiveness

We looked at different ways to develop your style and change your script by adjusting the slant and guidelines, or adding flourishing. You can make changes to the serif and sans serif alphabets to make them your own, too. The serif and sans serif alphabets shown in this book provide a basic structure for you to play with. Just make sure that whatever changes you make, you apply them to applicable areas of the alphabet to ensure cohesiveness overall. This ensures that when you use your modified alphabet in a design, the letters will look like they belong to the same alphabet (i.e., have the same style and, therefore, look not only appealing but legible at the same time).

For example, let's revisit the lowercase sans serif alphabet. To give it some personality, I have added dots as an embellishment to some of the letters on page 76. Notice that most of the dots have been added to curved strokes. Since I added a dot to the inner part of the oval on the letter b, I did the same for letters d, p, and q. I tried the same for the letter a but I didn't like the way it looked so I tried a different style of the letter a with a dot, and I liked that better. A dot was added to the top or at the beginning of the oval on the letter c, so the letter o has the dot in the same place. On the letter g, I added a dot to the descender, so to keep the look consistent, I also added a dot to the descender of letters j and y. I decided not to add it to the letter q because it already had a dot within its oval. When I added a dot to the letter r, I decided to change the look of the letter k to resemble that of the r.

a abcdefg
hijklmn
opqrst
uvwxyz

abcdefg
hijklmn
opqrst
uvwxyz

After making all the adjustments in pencil, I redid the alphabet with a brush pen to check the final look. Not all letters need to be adjusted but letters that are like each other were changed in the same way for consistency, which adds to the overall cohesiveness of the alphabet.

Let's look at another example of making a change and being consistent about it. Here is the uppercase serif alphabet. Instead of having serifs that are straight, I decided to make them curvy. In pencil, I added a curved serif wherever there was a straight serif on the original alphabet. I also decided to extend the crossbar of the letter A so that the curve would stand out; I did the same for the letter H for consistency.

ABCDEF
GHIJKLM
NOPQRST
UVWXYZ

ABCDEF
GHIJKLM
NOPQRST
UVWXYZ

Once satisfied with the changes, I redid the alphabet with a brush pen. As you can see, even a simple change to the basic structure of the alphabet gives it a whole new look.

Having a basic script, serif, and sans serif alphabet under your belt is the key to having flexibility with your designs. Furthermore, experimenting with these basic alphabets is how you will develop your own style. You might stick to something simple, or a special project may call for something more sophisticated. Over time you may prefer one look over another and then move on to someone else. It's a process—try to have fun along the way!

Creating Dynamic Layouts

When you go back to the idea of lettering as drawing, you know that the individual strokes are drawn and joined together with other strokes to create letters. These letters are then combined with other letters to create words, and these words come together to create a phrase or a quote, and so on. Whether you are lettering an individual word, a phrase, or a quote, you can make purposeful decisions about how these parts are put together so that the message in the words get across to its reader while being beautiful at the same time.

Simple Layouts

To create a simple layout, let's use all the basic skills of lettering you have learned so far. Stick with your own script. You may add in flourishes here and there to help fill negative space and provide balance to the whole look. But for the most part, keep it simple now and consider more elements later in the section Complex Layouts.

The following example will take you through the process of creating a layout with your script lettering alone. Feel free to make any modifications that you feel work best for your script and the layout. For any given set of words, there are many possibilities for a layout. The example shown to you is meant to demonstrate just one of these ways.

Example #1: Make Today Amazing!

1. Consider the overall shape you would like the words to take. Think of boxing in the words into a rectangular shape in either portrait or landscape orientation. In layout 1, you could have one word on each line creating a portrait orientation (a vertical, rectangular shape). Layouts 2 and 3 are landscape orientations, or a horizontal rectangular shape. This configuration means you could have all three words go across in a single line or you could have the words "make" and

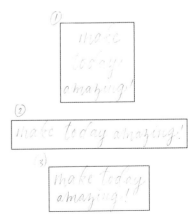

"today" on one line, and "amazing" in the second line underneath. Use a pencil and sketch each of the possible layouts. Then decide which one you will move on with.

2. Layouts 1 and 3 are the most compact. Let's further explore #1, where the words are stacked on top of each other in portrait orientation. To further improve on this layout, look for negative space that can be filled to fit the overall rectangular shape of the whole piece. One way to find the negative space is to box in each of the words. Go ahead and do this with a pencil if necessary. In each of the negative spaces, look for a letter that can be easily flourished, such as those with ascenders or descenders, and sketch the flourishes in. Revisit the flourishing section of this chapter for ideas. Because all of this is done using a pencil, you can erase and touch up any areas you feel need more attention.

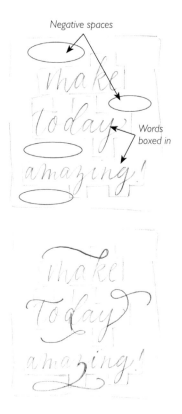

Negative spaces

Words boxed in

3. Once you are happy with the overall shape and look, it is time to ink. If you're using any of the smooth paper suggested in Chapter 1, you can go ahead and use a brush pen to trace over your sketch, then erase the pencil lines afterward. If you're using regular copy paper for your sketch or anything that is not smooth enough for your brush pens, use tracing paper on top and trace over your sketch with the brush pen.

Example #2: Say Yes to New Adventures

1. Consider the overall shape in both portrait and land-scape orientation. Especially for longer phrases or quotes, it's also important to consider the overall flow of the words as the reader reads them. For #1, in portrait orientation, the words "say yes" are in the first line separated from "to new" in the second line, and finally, the word "adventures" sits alone on the third line. Look for a way to avoid ascenders and descenders from conflicting with each other. For example, by purposely placing the word "to" underneath but to the left of the letter y in "say," you avoid the top portion of the letter t in "to" from overlapping the descending stem loop of the y in "say." Both #2 and #3 have overall shapes that fall into landscape orientation except the words have been broken up differently. In #2, "new" and "adventures" pair nicely together. Notice that this second line has been centered and that the ascending

Sample layouts

stem loop of the d in "adventures" does not conflict with the descending stem loop of the y in "yes." In #3, "adventures" stands alone in the second line. The ascending stem loop of the d in "adventures" has been tucked in between the descending stem loops of the letter y in words "say" and "yes" to avoid overlap, fill in negative space, and somewhat center the word underneath the first line.

2. Choose one of the overall shapes to further explore. Let's work on #2. Consider the overall rectangular shape in landscape orientation, as well as the negative spaces within that shape. Box each of the words in, if necessary, so that you can easily see where these negative spaces are. Now look for letters that can be flourished to fill in these nega-tive spaces. Since you are working with pencil at this stage, keep experimenting with the flourishes and redo them if necessary. Also, look to fill in space above and below the overall piece.

Top: boxed words easily identify negative spaces circled in red. Bottom: penciled flourishes in the identified negative spaces.

3. Trace over the pencil guides. Once you are satisfied, trace over the piece (a small-tipped brush pen was used here because the sketch was done on a small scale) and erase the pencil lines.

Alternatively, take a new piece of smooth paper and redo the piece in your favorite brush pen, small- or large-tipped.

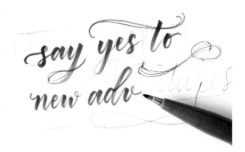

Complex Layouts

Complex layouts involving multiple words will essentially allow you to apply everything you have learned so far, from the basics of lettering to flourishing, embellishing, letter style, and applying decorative elements. The possibilities are endless when it comes to planning the layout of any piece. The final look is entirely up to you and what you feel fits your personal style. The goal of this next section is to walk you through a process that helps you to consider many aspects of creating a piece that is both visually appealing and communicative through the meaning of the words and the emotions that they evoke.

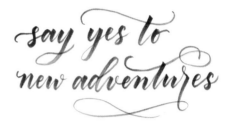

Top: tracing the penciled letters with a small-tipped brush pen. Bottom: finished lettering.

1. Write down the phrase or quote. Read it carefully and think about which word or words can be emphasized to highlight the meaning behind the whole message. Mark these words by underlining or circling them. These will be your key words. Even within a set of key words you could have some that you think are more important than the others. Essentially, you could have two to three levels of importance, in terms of the words, in your whole piece.

2. Decide how you will differentiate the look between the key words and the other supporting words. How will they stand out and capture the reader's attention? Going forward, jot down your ideas next to your quote for reference.

 Consider the style of the letters: The style of letters can differ by the type of alphabet (e.g., script, sans serif, and serif). If the key words are lettered in your script style, then the remaining, less important words can be lettered in a sans serif or serif style. Whichever style you choose for the key words, pick a different one for the other words.

 If you keep the style of lettering the same for all the words, you can still change the look of the key words by changing the slant, spacing, size of loops, guidelines, etc. For example, the key words could be lettered at a slant while the others are lettered straight up and down. By the same token, the key

words could be written with the letters spaced out wide while the others are lettered at your normal spacing. Revisit the suggestions laid out earlier in this chapter for more ideas.

Consider the size of the letters: If you keep the style of the letters the same for the whole phrase or quote, an easy way to make the key words stand out is to change their size. Letter the key words on a larger scale or make the letters thicker. Keep the rest on a smaller scale.

Consider embellishments: Embellishments are like the decorations on a cake. You can apply them to the whole piece or just to parts of it. Again, revisit the ideas presented to you earlier in this chapter for ideas on how to embellish your letters.

3. Choose your color(s). Color alone can evoke specific emotions from the reader—reds and pinks for quotes on love, bright happy tones for phrases on happiness, or dark, rich colors that can enhance a deep or thought-provoking message. Use color to enhance the message inherent within the words.

Tip: Steps 2 and 3 contain a lot of options. Instead of using too many of the ideas all at once, choose a few of them and keep the overall design on the simpler side. Doing this will allow the message within the words to be communicated more clearly while still having a visually appealing design.

4. Think of the overall shape your design will take. In the Simple Layouts section on page 77, we mainly discussed the idea of having the words lettered on horizontal lines within a rectangular shape overall, and having that rectangle be set in either landscape or portrait orientation. This time, consider having some of the words on a diagonal, on an arc, on a wave, or within a shape.

5. Using the ideas you have jotted down, sketch out your overall design in pencil. While sketching, don't be surprised if you find yourself modifying your original idea for the layout. Remember that it is a process, and erasing and redrawing, or even discarding or substituting, other ideas is expected at this time. Use other decorative elements, if necessary, to fill in negative space and provide balance to the overall design. They can be flourishes, banners, simple lines and shapes, or even illustrations. Make an assessment about whether adding decorations actually enhances the overall design and, if not, leave them out.

6. Once you are satisfied with your pencil sketch, it is time to ink!

The next section will walk you through the process of designing a layout with specific examples. As you follow the steps, remember that the choices made here are my own and are based on the way that I interpret the quote. You may interpret the quote differently and that may lead to different parts of the quote being emphasized. You also have an amazing repertoire from which to draw on to create a piece with the exact same words in a style that is completely yours. Feel free to make changes as you see fit; after all, these are just suggestions.

Quote #1: All Good Things Are Wild and Free –Henry David Thoreau

1. Write out the quote and look for the most important words. Underline the key words; here they are "good things," "wild," and "free." All the remaining words are supporting words.

2. Now it's time to make some decisions on differentiating the look between the key words and the rest. I've chosen to letter the key words in a bouncy script style at a larger scale than the supporting words. Since I naturally write on a slant, I will keep this slant with the key words. The supporting words will be lettered in capital letters in a sans serif style and will be smaller than the key words. These words will be simpler and written straight up and down. Shadows will also be added to the whole piece to make the lettering pop.

3. When I read this quote, it reminds me of the things in life, tangible or intangible, that are all around us and are mostly free, such as the air we breathe and the water we drink, or the relationship between humans and the planet. Images of the world and its greenery immediately come to mind so I feel that the color green would work well for this piece. The key words will be lettered in different shades of green to create an ombré effect, and the supporting words will be lettered in dark green so that they do not stand out as much.

4. I'm ready to sketch an overall layout or two. In the first layout, the words are staggered vertically one by one. In the second layout, I have sketched the words "good things" on an arc and have tucked in the word "are" underneath the arc to fill that space. Then the words "wild" and "free" written horizontally close off the whole piece quite nicely. Taking a step back from the piece, I notice that I could add simple flourishes and laurels to fill in the negative spaces. Laurels make a great decorative element and, for me, complement the meaning of this quote.

Sketches of potential layouts, one vertical and the other square

5. The layout I choose to ink is the one that overall fits into a square shape. When I sketch the piece onto final paper, I letter all the words and add in the decorative elements exactly as I would like them to look. I even swapped out the lines surrounding the word "are" and decided to flourish the letter g of the words "good" and "things" to fill in negative space. I do this all with a light hand so that the pencil lines can be erased afterward.

Tip: Use grid paper and a light pad underneath your work so you have guidelines to work with.

6. Finally, the piece is ready to ink. First, I letter all the key words in light green and the flourishes and the supporting words in dark green. Then, I go back to the key words and created an ombré effect. Next, I used a gray brush pen to add shadows to all the lettering. Finally, I add in the laurels and use an ombré effect on the leaves to create more dimension. Erase all the pencil lines and the final piece is ready!

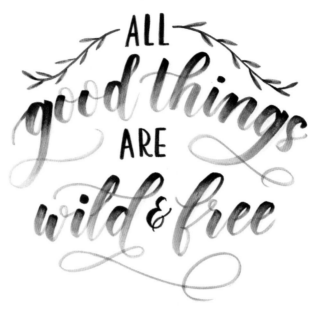

Quote #2: Shine Like the Whole Universe Is Yours –Rumi

1. Write the whole quote to figure out which words are important. Underline the key words; here they are "shine," "universe," and "yours." Since I feel that the whole point of the message is in the two words "universe" and "yours," I plan to make these two words stand out the most in my design. The word "shine" will also stand out, but not as much as the other two. So, all in all, the words in the quote have three different levels of importance. "Like," "the," "whole," and "is" will act as the supporting words.

2. Now I focus on how to make the key words stand out. I feel that "shine" will look best in sans serif capitals, the words "universe" and "yours" in serif capitals, and the supporting words drawn at a smaller scale in script lettering. Simple flourishes and stars will fill negative space.

3. For the colors, I choose black and different shades of purple and pink to create the look of outer space. The words

Notes on differentiating the key words from the supporting words

"shine" and "universe" will have a blended effect, but I will also add stars to "universe" to make it look like a galaxy. This will emphasize the importance of this word compared to "shine." The supporting words will be done in either black or dark purple.

4. Now I'm ready to sketch possible layouts. I play around with the words and try a couple of different layouts. I choose the one that is more compact. Sometimes, if I know one word is going to be larger than the previous, I sketch the larger word first then tuck in the smaller one afterward. For example, I sketched in the word "whole" and stretched it out so that it would be around the same length as the words "shine" and "like" for balance. Then I went back and put the word "the" in the space between the words "shine" and "whole" in the empty space. I also changed the word "yours" from serif capitals to larger,

Sample layout

mixed lettering so that it doesn't take attention away from the word "universe" but still stands out on its own. Finally, I notice that I can fit the whole piece into the shape of a circle. I sketch the circle shape around the words and adjust the lettering within it so that the overall shape will appear circular in the end.

5. I resketch the overall design onto a new sheet of paper and ensure that I have all the elements I thought of while doing the initial sketch. I'm not too concerned about having a perfect circle so I just freehand it and then letter in the words and decorative elements.

6. I'm ready for inking. First, I letter all the supporting words in dark purple using a small-tipped brush pen to make it easier to letter at a smaller scale. Then I letter the key words in light purple and use black, dark purple, and a colorless blender pen to create a blended effect. Next, I go back to the word "universe" and use a white paint pen to add in the stars. Finally, I use a gold brush pen to draw in different-shaped stars around the words to balance the whole piece, then erase the pencil lines to present the final look.

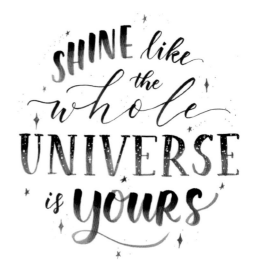

More Tips on Creating a Layout

One word to always keep in mind is consistency. Just as this has been critical for the exercises throughout this whole book thus far, it is equally so to create a great layout. Pay attention to the following:

Consistency within a style of alphabet: Whether you use one alphabet or three within a layout, make sure that the style of each alphabet is consistent. Ensure that the x-height is the same for each letter, the ascender and the descender loops are the same size, downstrokes are of the same thickness, letters are angled in the same direction and to the same degree, etc. All the words in a layout lettered in the same style should be easily identifiable as belonging to the same alphabet.

Compare the following two photos. The one on the left shows the original layout; the one on the right is marked up showing what can be fixed.

Angle of strokes is inconsistent within the word

Upstroke in uppercase M thick; not consistent with the other M

Size of uppercase serif letters is inconsistent

Not enough space between these lines at these points

Words too close together

Too much space between letters compared to rest

Consistency with spacing between words and lines of words: Layouts often consist of multiple lines of words and because of that, a common mistake is to either have inconsistent spacing between words or between lines of words. Inconsistent spacing between words may result in leaving awkward negative spaces which, in turn, may leave the whole layout looking unbalanced. This may be remedied by moving words over, moving a word to another line, or filling those negative spaces with flourishes or a doodle. Spacing between lines that is either too narrow or too wide will leave a portion of the layout appearing squished and, once again, unbalanced.

Don't be surprised if you find yourself redoing a layout or making several tweaks here and there. To make this process easier, the top tools I can suggest, besides a pencil and eraser, are tracing paper and a light pad.

After you pencil a layout, make a draft with a brush pen. Look for inconsistencies or other areas that you would like to adjust and mark them up with a colored pen. Now, here is when the tracing paper comes into play. The beauty of tracing paper is that when you place it on top of your draft, you will be able to see right through it. As you re-ink the layout section by section, you can keep the parts you are happy with by copying them directly and make the necessary changes to the other parts.

The light pad will come in handy when creating the final piece. Place the draft done on tracing paper underneath the paper you would like to use for final presentation (for example, laser printer paper, cardstock, or Bristol paper). The light pad will shine light from underneath, allowing you to see the layout and copy it directly. It's no wonder that the light pad has become one of my favorite tools besides the brush pen itself.

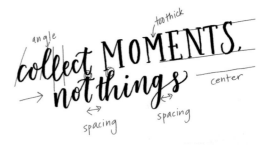

With a colored pen, mark inconsistencies on the draft done with a brush pen.

Use the brush pen draft as a guide to create the final piece, adjusting the lettering according to the notes in color.

Compare the two layouts from before (left) and after the changes (right):

By knowing what to look for in a well-balanced layout and having the right tools, you will be able to make purposeful changes that lead to dynamic and visually appealing layouts every single time!

CHAPTER 6

DIY Projects–Putting It All Together

In this chapter, I will walk you through some practical projects that are easy and sure to please. They are straightforward and meant to give you a starting point for applying your brush lettering skills. You can either follow the steps as given or feel free to add in your own ideas to make the final outcome your own. More importantly, be creative and just have fun!

Gift Tags

Gift tags are a super fun and easy way to bring your gift-wrapping skills from simple to chic. A handmade gift tag allows you to customize the whole look and add the perfect finishing touch. Use one to write the name of the recipient or a simple and sweet message to fit the occasion! This tutorial will show you how to make a template for any style of gift tag so that it can be traced repeatedly on different types of paper.

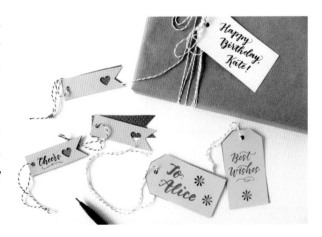

Tools and Supplies

- Grid paper
- Pencil
- Ruler
- Scissors
- Assorted neutral-colored cardstock/Bristol paper
- Single-hole puncher
- Small-tipped brush pen
- Ribbon/string/twine

Instructions

1. Make a template in the shape of your choice on grid paper. Using grid paper allows you to make symmetrical tags without having to fuss with a ruler for making specific measurements. Use a pencil and a ruler for your straightedge to draw in the lines and adjust where necessary. Draw a hole where you will be punching one in so you can see the finished look.

Determine the size of the gift tag by thinking ahead on how you are going to use it. Lettering someone's name on a tag will require less space than a simple message like "Happy Birthday!" or "Happy Holidays!" You may want to make different-sized tags of the same shape for this purpose.

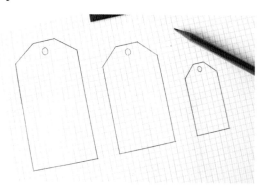

2. Cut out the template.

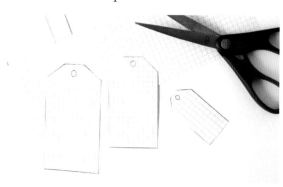

3. Place the template on top of your neutral-colored cardstock (such as white, off-white, or light gray) and, using a pencil, trace it as many times as the number of tags you need. The reason for using neutral-colored cardstock is so that you can easily see the lettering on top of it.

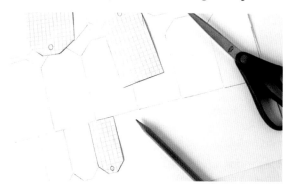

4. Cut out all the tags and erase any visible pencil marks along the edges. Use a single-hole puncher to punch a hole for the string.

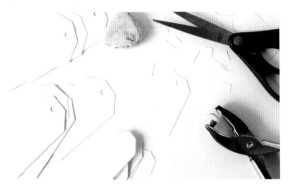

5. Letter the name of the recipient or a sweet and simple message. If necessary, use a pencil to sketch the lettering in first, then trace using your favorite small-tipped brush pen. Don't forget to erase the pencil lines!

6. When it is time to use your gift tag, cut a piece of ribbon/string/twine and slip it through the hole to tie the gift tag to a gift or affix the tag to the ribbon/string/twine that you use to wrap the gift.

Layered Gift Tags

A layered gift tag is essentially two gift tags in the same shape and size, layered on top of each other. The front layer has a shape punched out of it so one can see the back layer through it.

Additional Tools and Supplies

- Two different-colored cardstocks (one in a neutral or light color, the other solid-colored or patterned)
- Paper punchers in various shapes

Instructions

1. Place the tag template created in the basic tutorial on top of one of the cardstocks and trace it. Do the same for the other piece of cardstock you chose.

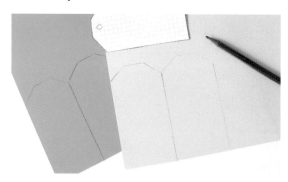

2. Cut out the tags from each of the cardstocks. Punch a shape out of the cardstock you chose for the front layer using a paper puncher.

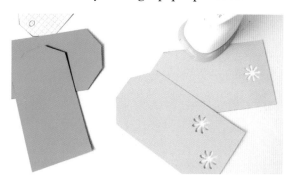

3. Line up the tags on top of each other and use your single hole puncher to place a hole in the appropriate place.

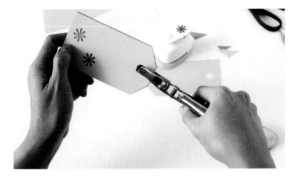

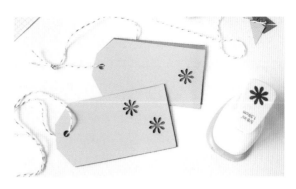

5. Now your tags are ready for lettering the name of the recipient or a sweet sentiment!

4. Weave your choice of ribbon/string/twine through the holes.

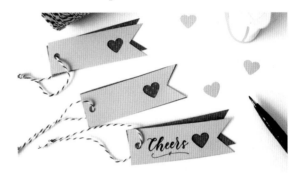

Wrapping Paper

Customizing your own wrapping paper is a great way to add a handmade touch to your gift and will surely bring a smile to anyone who receives it! Blank or solid-colored wrapping paper is the perfect canvas for lettering a word, phrase, or sentiment that complements the occasion for the gift. Whether it be for a birthday, graduation, or special holiday, customized wrapping paper is sure to please.

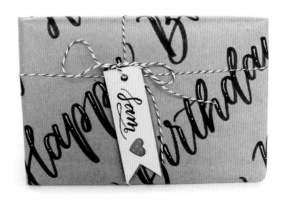

Tools and Supplies

- Scissors
- Solid-colored wrapping paper (kraft or white work best)
- Weights for the corners
- Assorted brush pens

Instructions

1. Cut out a piece of wrapping paper large enough for the gift you want to wrap.

2. Lay the paper down flat with the outside facing up. Use something heavy on the corners to keep the paper from rolling back up.

Think of a word, phrase, or sentiment that fits the occasion for the gift. It could even be a favorite quote or the lyrics of a song that the recipient is fond of.

Tip: Test the brush pen(s) on a scrap piece of wrapping paper. This way there will be no surprises once you start working on the actual one.

3. Start at the left side of the paper and letter the word or words. You can work horizontally or on a diagonal. Repeat this across the whole piece of paper to create a pattern. When you get to the edge on the right side, letter right to

the edge if necessary. This will make it appear that the piece of wrapping paper was cut from a whole roll with the same lettering design.

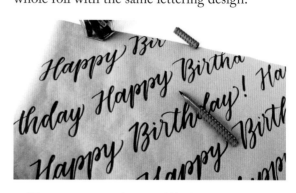

4. Keep repeating the word(s) down the piece of wrapping paper until there is no space left. Add embellishments if you would like. Here I added highlights to add interest to the lettering. Your wrapping paper is now ready to be used!

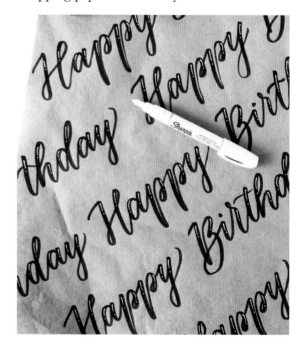

Place Cards

These simple place cards will dress up any table. They can be modified in many ways to suit any occasion, whether it is a dinner party, wedding reception, workshop, or birthday party. They can be used as gift enclosures, too!

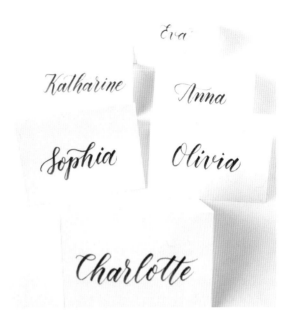

Tools and Supplies

- Cardstock/ Bristol paper
- Pencil
- Ruler
- Craft knife/ paper cutter
- Bone folder
- Scrap paper
- Small-tipped brush pen

Instructions

1. Measure out 3.5 x 5-inch cardstock and repeat this for as many place cards you need.

2. Cut out each place card to 3.5 x 5 inches. On both long sides of each cut-out card, mark the middle at 2.5 inches. These lines will be used to score the card and make a clean fold.

3. Take your ruler and line it up to the pencil guides that mark the middle of the long sides. Place your bone folder against the ruler and, using pressure, score a line from one end to the other.

Line up ruler here

4. Fold the card on the indentation left by the bone folder. The folded place card should now measure 3.5 inches long and 2.5 inches wide.

2.5"

3.5"

Steps 5 and 6 are optional.

5. You can freehand the names and sketch them in using a pencil, but if you would like to be more precise, draw in guidelines. A less time-consuming way to do this is by making a master guideline template. Trace a place card on a piece of scrap paper and pencil in a line where the folded edge would be. Using a ruler, measure and draw in guidelines suitable for your lettering. If you are just doing a first

name, center the guidelines in the middle of the card. If you are doing both first and last names, create guidelines to fit either the whole name in one line or in two lines. Extend the guidelines over the edge of the place card template. Also, measure and draw in a vertical line at the center of the place card. This will help you to center the names later.

6. Place each place card onto the guideline template. Use a ruler to match up the guidelines that were drawn over the edge of the template and draw in a light pencil line matching these guidelines on to the place card. Repeat this for all place cards.

7. Use a pencil to sketch in all the names to ensure they will fit. To center the name, count how many characters there are in total. Divide the number of characters in half to figure out which character would have to be in the middle. If lettering both first and last names, count the space in between as one character. Use the pencil line drawn vertically through the middle of the place cards as the guide for centering.

8. When you are satisfied with the sketches, use a small-tipped brush pen to ink. Erase all the pencil lines created while measuring and sketching. Re-fold the place cards. They are now ready to use for your special occasion!

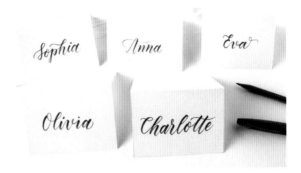

9. Optional: For a whimsical look, flourish to the edges of the place card on both sides.

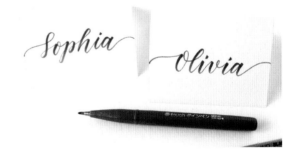

Watercolor Splash Greeting Cards

Throughout the year, celebrations abound, whether they be birthdays, weddings, graduations, or other joyous occasions. Use a card to send a greeting or well wishes, or as an invitation to an event. The watercolor splash in the background will surely put a smile on the recipient's face!

Tools and Supplies

- White cardstock/ Bristol paper
- Ruler
- Pencil
- Craft knife/ paper cutter
- Bone folder
- Two to three water-based brush pens
- Blending palette/ plastic sandwich bag
- Water
- Paintbrush
- Paper towel
- Paper weight

Instructions

1. Measure out 6 x 8 inches on the cardstock.

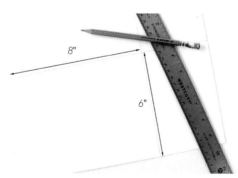

2. Cut out each card. On both long sides of each cut-out card, mark the middle at 4 inches. These lines will be used to score the card and make a clean fold.

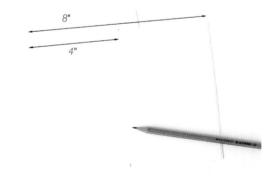

3. Take your ruler and line it up to the pencil guides that mark the middle of the long sides. Place your bone folder against the ruler and, using pressure, score a line from one end to the other. Fold the card on the indentation left by the bone folder. The folded greeting card should now measure 6 inches long and 4 inches wide.

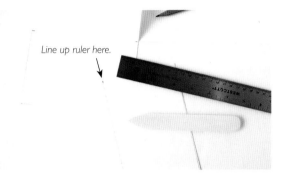

Line up ruler here.

4. Create the watercolor splash on one side of the greeting card. To do this, choose two to three brush pens in colors that you feel would go together nicely or match well with the occasion. Test the combination on a scrap piece of cardstock. Once satisfied with the color combination, use one brush pen at a time and transfer ink onto a plastic sandwich bag by swiping the tip back and forth. Do this in a random fashion but within an area that is smaller than 6 x 4 inches.

5. Apply water to one side of the greeting card with a paintbrush. Make sure the card is wet within the area you would like the splash design. Do not oversaturate the card.

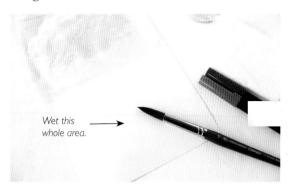

Wet this whole area. →

6. Flip the plastic sandwich bag over (ink side down) onto the wet greeting card. Press down and spread your fingers across the bag to ensure that the ink transfers onto the card. Although you could use a blending palette or other nonporous surface for this step, the transparent sandwich bag allows you to see what exactly is happening.

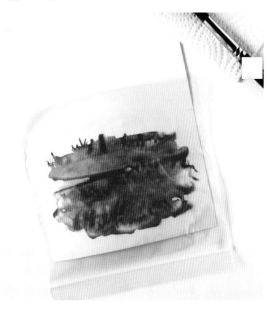

7. Carefully lift the sandwich bag off the card. Be careful that water does not drip back onto the card from the bag. Use a paper towel to dab off extra water on top of the card and wait for it to dry. The resulting watercolor design will be different every time! If the greeting card warps due to the moisture, place it underneath your paper weight or something heavy to flatten it out.

8. Letter a greeting or sentiment (such as "Happy Birthday!" "Congratulations!" or "You're invited!") on top of the watercolor design. Use a brush pen in a color that will stand out against, but also complement, the watercolor splash.

Fancy Snail Mail

An envelope provides the perfect little canvas for beautiful lettering. Surprise a friend or family member with a card or letter by sending some good ol' snail mail or spruce up invitations for a baby shower, bridal shower, or wedding.

Tools and Supplies

- Blank envelopes (various sizes)
- Ruler/sliding ruler
- Pencil
- Scrap paper
- Assorted brush pens

Instructions

1. Choose a blank envelope in your desired size. Here, I chose one with 5 x 7-inch dimensions.

2. Make a master guideline template (see Place Card project Step 4 on page 94). This especially comes in handy for any project requiring several envelopes and saves you time in the long run. By figuring out the measurements once, you can simply draw guidelines for every envelope thereafter without having to think about being accurate.

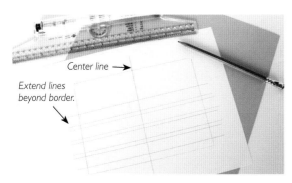

Center line →

Extend lines beyond border.

Trace the envelope on a piece of scrap paper. Using a ruler, measure and draw the center line extending it beyond the border of the envelope template. Do the same for the name and address. For this template, I have drawn in lines 15 millimeters apart for the lettering of the name and address with 5 millimeters of space between each of the lines for lettering.

Remember to extend the guidelines beyond the borders of the envelope template. You can use a regular ruler to measure all these lines, but I have used a sliding ruler. This tool allows you to draw parallel lines with ease.

Tip: Leave extra space at the top of the guideline template for the stamp(s).

3. Place each blank envelope onto the guideline template. Use a ruler to match up the guidelines that were drawn over the border of the template and draw in a light pencil line matching these guidelines on to the envelope. Repeat this for all envelopes.

4. There are many ways to style an envelope, but for this example I will show you how to center each of the lines. For each line, count the number of characters (including spaces and punctuation). Divide this number in half to figure out the center character. Aim for this center character to lie on the vertical line drawn to mark the center of your envelope.

Number of characters

Middle character

5. Once you have figured out where the center of each line of lettering is, sketch it out onto the envelope. Sometimes it is easier to letter the word that is closest to the center first and then letter the rest around it. Once you are done sketching, it should look something likes this:

6. Once you are happy with your sketch, it is time to ink! Small-tipped brush pens work well since envelope addressing usually requires small-scale lettering. Choose a color that will complement the occasion for sending an envelope. When finished, erase all the pencil lines. Just add a stamp and your envelope is ready to be sent!

When it comes to lettering on envelopes, there is no limit to creativity. Use it as an opportunity to play around with different styles, proportions, color combinations, and embellishments. If a brush pen doesn't work, use any other writing tool, such as the Sharpie Paint Pen, for more options, and draw your letters like you would for faux calligraphy (see Chapter 7).

Faux Calligraphy

What is faux calligraphy? It is calligraphy created with any of your standard writing tools, such as a ballpoint pen, bullet tip marker, pencil, crayon, or even chalk. This technique allows you more opportunities to create calligraphy on other mediums that would normally not be possible with just your brush pens, or perhaps the surface is too rough and is likely to ruin the tips of your brush pens. This technique is also handy when projects require calligraphy on a larger scale than what your brush pens are capable of. With your knowledge of the letterforms and where the downstrokes are placed, you'll be able to create faux calligraphy easily just about anywhere. No surface is safe from being turned into a calligraphy project!

Making Faux Calligraphy

1. Write the word or phrase. Choose a writing tool other than a brush pen such as a ballpoint pen. Use it to write a word or phrase in cursive handwriting, but leave a little extra space between the letters to make room for the thick downstrokes.

2. Identify the downstrokes. To achieve the look of calligraphy characterized by thin and thick downstrokes, you'll need to identify where the downstrokes are. Use your knowledge of the letterforms—every time you would pull down

with the brush pen is where the downstroke would be.

3. Draw new lines to add weight. To achieve the final look of thick downstrokes, draw lines that are parallel to and follow the natural contour of the initial monoline downstrokes. You can draw the new lines to the left or the right of the monoline downstrokes, wherever there is more space. As you move through the whole word, ensure that the width of the thickened downstrokes is consistent throughout.

Once you move through the whole word or phrase drawing in your new lines, it should look like this:

4. Fill in the thickened downstrokes. With your new lines drawn in, fill in the empty space with your ballpoint pen.

Once you are finished, the thickness of your downstrokes will look as if they were done with your regular brush pens. They will provide a nice contrast with the thin upstrokes in the word!

Tip: Faux calligraphy also requires practice over time, so don't fret if it looks "off" to you. Go back to the letterforms you created with a brush pen and look specifically at the shape of the downstrokes, particularly at the tops and bottoms. How the line curves or where it starts and stops are the details that will make your faux calligraphy look polished.

Chalkboard Faux Calligraphy

Perhaps you require a sign for an event—chalk and calligraphy really provide that look that is elegant yet rustic and approachable.

What tools work best: Any type of chalk works. A chalk sharpener is also essential. Look for one that has two different-sized holes; chalk will fit into the large hole.

For a cleaner look, paint pens such as the Sharpie Paint Pen work well. This one comes in two versions: water-based and oil-based. Either works fine but the water-based one can easily be erased with a damp cloth. The oil-based one can be wiped away as well but it will take more elbow grease. Another advantage to using paint pens versus real chalk is that your work won't be ruined if something rubs against it by accident.

Glass Faux Calligraphy

You can add a personal touch to a gift or add labels to pantry items.

What tools work best: I would suggest using a type of paint pen on glass, such as the Sharpie Paint Pen. To wipe off any mistakes, use a damp cloth. Both water-based and oil-based pens work fine except it will take more effort to remove mistakes created with an oil-based pen.

When in need of guidelines, use a chalk marker in conjunction with a paint pen. Chalk marker will show up well on glass and can be erased easily with a dry paper towel. Leave the guidelines you create with a chalk marker (and a ruler), then use a paint pen to do your lettering. Afterward, just take a dry paper towel and wipe away all the guidelines! The lettering created with the paint pen will stay in place.

Embossed Faux Calligraphy

Some projects call for a bit of metallic goodness! Embossed lettering creates a raised effect and can be applied to tricky surfaces such as kraft gift bags, journals, and more!

What tools you need: For embossing, you need an embossing pen that has specially formulated ink that stays tacky for a while before it dries. Embossing pens come in either a bullet or brush tip, hence, requiring faux calligraphy depending on what you have. You also need embossing powder, which comes in a variety of colors, as well as a craft heating tool.

After using the embossing pen to create faux calligraphy, you cover the area with embossing powder. Next, you remove the extra embossing powder (which can be put back into the container) and you will see that some of it has adhered to the ink from the embossing pen. Finally, you take a craft heating tool and heat the embossing powder until it has melted and become shiny.

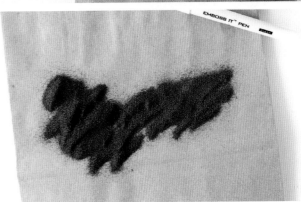

CHAPTER 8
Beyond Lettering

Get Involved in the Community

I remember browsing through my Instagram feed when I stumbled upon an image containing beautiful hand lettering, and I was instantly enthralled. Memories from childhood of when I experimented with a calligraphy kit came to surface and I knew that, for me, now was the time to learn. So, I searched the Internet for beginner's tools and supplies and, before I knew it, the brush pen had become my newest obsession.

On this budding creative journey of mine, I came across several Instagram accounts that featured lettering artists and calligraphers from all around the world. Some were accounts that curated and featured the work of artists of all different styles and skill sets. Some were established business owners who made a living out of their skills. Other accounts belonged to people who simply shared their interest by showcasing their own work and all things related to brush lettering or calligraphy. Furthermore, there were beginners just like me who were just getting to know the brush pen—everything from where to buy it to how to hold it, what paper works best with it, and so on. I decided to create an Instagram account, too, mainly to document my progress—a digital scrapbook, if you will—and to follow the accounts of those whose craft I admired.

It became more than that, though—it became a place where I found community. Although it takes some level of vulnerability to share your work with the world, open to judgment and criticism, sharing gives you an opportunity to connect with fellow artists. Engaging with others who share a love for lettering and calligraphy makes learning that much more exciting. I am continually encouraged and supported by other artists and I learn so much from them about technique, tools, and different styles. In turn, as my learning progresses, I can share what I know and answer any questions as others have graciously done for me. If I haven't made it clear enough, I highly recommend putting yourself out there, whether it's

on Instagram, through your own website, or on any other social media platform, and sharing your work. Look for and surround yourself with like-minded people who love to create just as much as you do.

In addition to engaging with people in the digital world, you can always find or, better yet, organize your own meet-up in your local community. Go out there and meet the faces of the people behind those Instagram accounts, learn about their journeys and their lettering experiences, or simply connect with them about life in general. Having a passion for this craft is the common element will instantly connect you to each other.

Avoid the Comparison Trap

The more you invest into learning lettering, the more you will be exposed to others who letter, especially those who have become quite advanced in their skill set. They are the ones you may look up to, the ones that inspire you. Their work is stunning. Every. Single. Time. Regardless of which tool is used, beautiful lettering is achieved; they make it look so easy. Their layouts are so eye-catching and on top of that, the photos they take of their work are so bright and well-composed. Scrolling through their feeds provides so much inspiration, yet they may make you feel inadequate and frustrated at the same time.

The thing with learning any new skill is you want to be great at it right away. I completely understand! You want results now and forget that becoming good at something takes a lot of time and practice. You have to remember that social media, Instagram in particular, is a place where people curate their best work. It's only natural that you would want to put your best foot forward and show what you are proud of. What you don't see is all the behind-the-scenes work that goes into creating content for a feed. Unless you have been engaging with an artist on Instagram and have had a chance to learn about their journey, you really don't know how much time has already been invested to produce the work that you see today. They could have started years or months before you, or they may even have the option to devote a few hours or more a day to their craft. When it comes to posting on Instagram, it can take several attempts to get the piece just right, not to mention numerous photos are taken to get the perfect shot. What you see is a snapshot of their creative journey, not the whole story. Keep this in mind the next time you find yourself comparing your work to others. Don't be so hard on yourself and remember that as long as you put in the time and be consistent with your practice, you will also progress. Learning to letter is a process that will have its ups and downs, but if you keep and an open mindset, you will only push yourself further and in a direction that is right for you.

Basic Strokes (7 mm x-height)

Place tracing paper on top and trace carefully. Now try it on your own!

Guide Sheet (7 mm x-height, 55° slant line)

A

W

B

D

A

W

B

D

A

W

B

D

A

W

B

D

A

W

B

D

A

W

B

D

A

W

B

D

Guide Sheet (7 mm x-height)

A
W
B
D
A
W
B
D
A
W
B
D
A
W
B
D
A
W
B
D
A
W
B
D
A
W
B
D

Guide Sheet (15 mm x-height, 55° slant line)

Guide Sheet (15 mm x-height)

A ————————————————————————————————————

W -

B -

D ————————————————————————————————————
A ————————————————————————————————————

W -

B -

D ————————————————————————————————————
A ————————————————————————————————————

W -

B -

D ————————————————————————————————————
A ————————————————————————————————————

W -

B -

D ————————————————————————————————————

Lowercase Alphabet (7 mm x-height)

Place tracing paper on top and try it on your own!

/ + ꜩ + ʋ = *a* *a a a a a a*

/ + ℓ + ℯ = *b* *b b b b b b*

/ + ꜩ = *c* *c c c c c c*

/ + ꜩ + ℓ = *d* *d d d d d*

/ + ꜩ = *e* *e e e e e e*

/ + ℓ + / = *f* *f f f f f*

/ + ꜩ + / + / = *g* *g g g g g*

Lowercase Alphabet (7 mm x-height)

Order of Strokes

Place tracing paper on top and try it on your own!

/ + l + v = h h h h h h

/ + v + · = i i i i i i

/ + / + · = j j j j j j

/ + l + o + v = k k k k k k

/ + l = l l l l l l

n + n + v = m m m m m m

n + v = n n n n n n

Lowercase Alphabet (7 mm x-height)

Place tracing paper on top and try it on your own!

/ + O + ◡ = o o o o o o o o

/ + ∫ + ♂ = p p p p p p p p

/ + ʔ + ∫ + / = q q q q q q q q

/ + v = r r r r r r r r

/ + 8 = s s s s s s s s

/ + ⸮ + ~ = t t t t t t t t

/ + v + v = w w w w w w w w

115

Lowercase Alphabet (7 mm x-height)

Place tracing paper on top and try it on your own!

$N + v = v$

$/ + v + v + v = w$

$N + / = x$

$N + / + / = y$

$n + z + / = z$

Uppercase Alphabet (7 mm x-height)

Order of Strokes

Place tracing paper on top and try it on your own!

\mathcal{N} + \sim = \mathcal{A} \mathcal{A} \mathcal{A} \mathcal{A} \mathcal{A}

\sim + \mathcal{l} + \mathcal{s} = \mathcal{B} \mathcal{B} \mathcal{B} \mathcal{B} \mathcal{B}

\mathcal{C} \mathcal{C} \mathcal{C} \mathcal{C} \mathcal{C}

\sim + \mathcal{l} + \mathcal{e} = \mathcal{D} \mathcal{D} \mathcal{D} \mathcal{D} \mathcal{D}

\mathcal{C} + \mathcal{c} = \mathcal{E} \mathcal{E} \mathcal{E} \mathcal{E} \mathcal{E}

\mathcal{F} + \sim = \mathcal{F} \mathcal{F} \mathcal{F} \mathcal{F} \mathcal{F}

\mathcal{C} + \mathcal{y} = \mathcal{G} \mathcal{G} \mathcal{G} \mathcal{G} \mathcal{G}

Uppercase Alphabet (7 mm x-height)

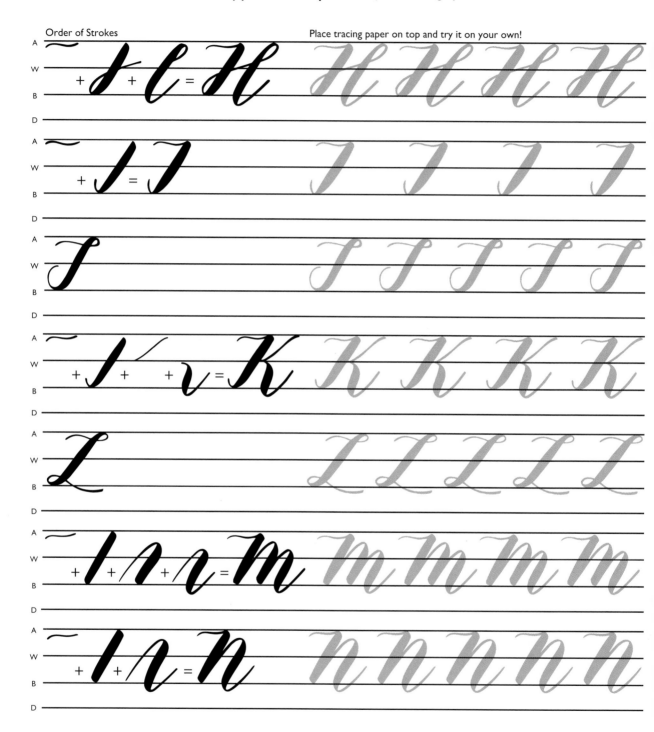

118

Uppercase Alphabet (7 mm x-height)

Order of Strokes

Place tracing paper on top and try it on your own!

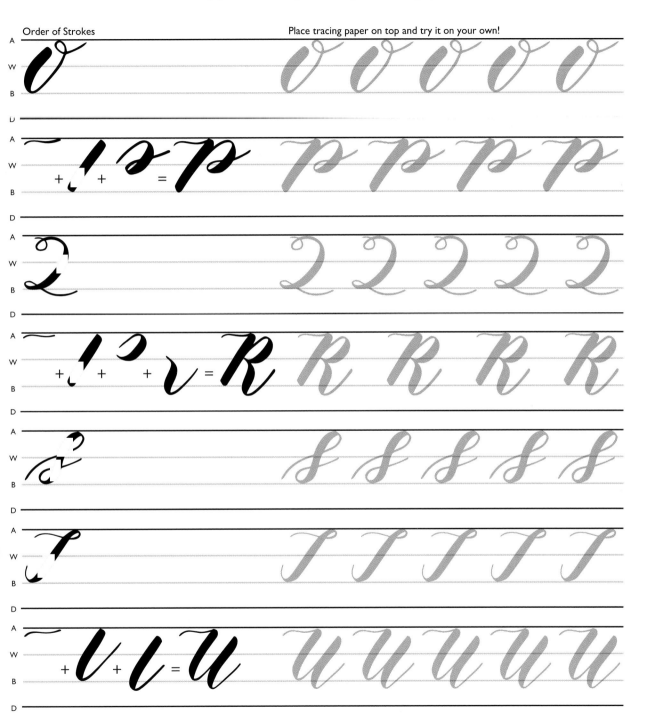

Uppercase Alphabet (7 mm x-height)

Place tracing paper on top and try it on your own!

A
W
B
D

\sim + \mathcal{V} = \mathcal{V} \mathcal{V} \mathcal{V} \mathcal{V} \mathcal{V}

A
W
B
D

\sim + \mathcal{l} + \mathcal{v} = \mathcal{W} \mathcal{W} \mathcal{W} \mathcal{W} \mathcal{W}

A
W
B
D

\mathcal{l} + $/$ = \mathcal{X} \mathcal{X} \mathcal{X} \mathcal{X} \mathcal{X}

A
W
B
D

\sim + \mathcal{l} + \mathcal{y} = \mathcal{Y} \mathcal{Y} \mathcal{Y} \mathcal{Y} \mathcal{Y}

A
W
B
D

\mathcal{l} + \mathcal{y} = \mathcal{z} \mathcal{z} \mathcal{z} \mathcal{z} \mathcal{z}

A
W
B
D
A
W
B
D

Commonly Used Words for Practice (15 mm x-height)

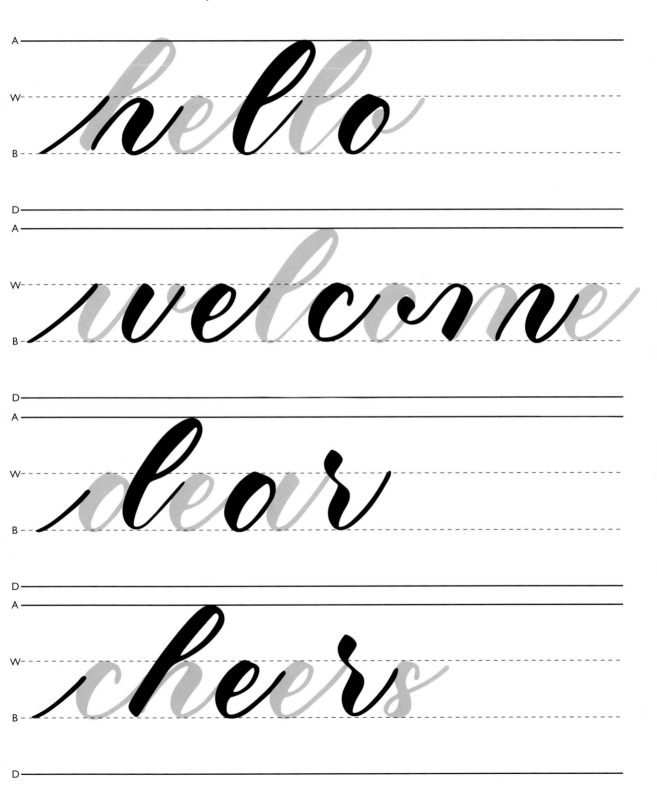

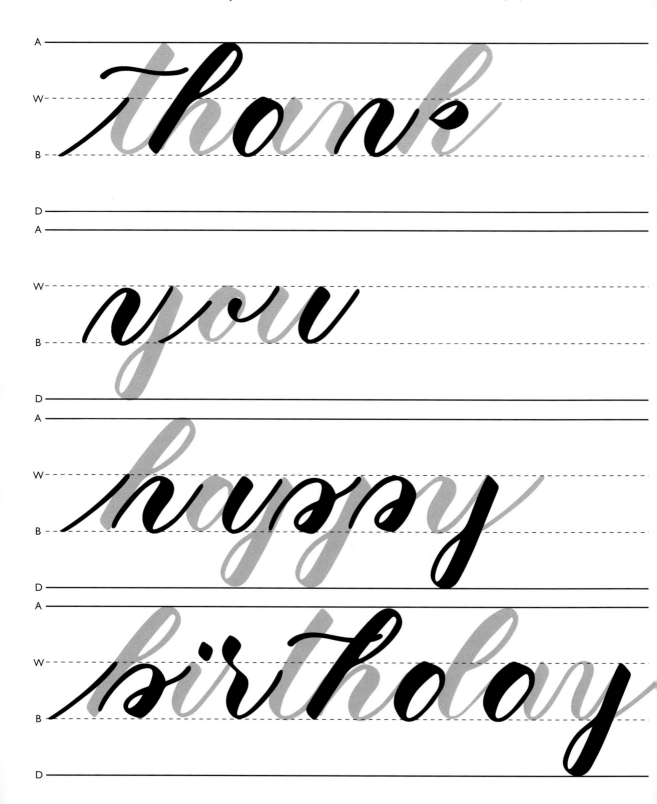

Acknowledgments

I am blessed to be surrounded by an amazing support system without which this book would not be possible. I would like to thank the following people:

My partner, Salv, for his encouragement and constant patience while I created this book, which required many hours spent at my desk or turning the living space into a makeshift art and photography studio. Explosions of lettering tools and supplies were a common occurrence!

My family and friends for supporting my endeavours and being my biggest cheerleaders. Your love, words of encouragement, and genuine excitement drive me to do my very best.

Bridget and the entire Ulysses Press team for having faith in me to take on such a grand project and for guiding me through a process that is entirely foreign to me. Thank you for an amazing opportunity to share my love for lettering.

The lettering and calligraphy community for taking part in shaping my creative journey and always being a source of encouragement and inspiration. The amazing talent that I meet either in person or online pushes me to keep growing, learning, and sharing.

About the Author

Grace Song is a hand letterer and brush calligraphy artist based in Toronto, Canada. As a young girl, she was always drawn to beautiful script and experimented with her very own calligraphy kit. Flash forward many years later, and her passion for all things hand lettered had been reignited. Beginning with learning one letter a day, Grace now creates dynamic, hand-lettered pieces with a variety of tools, including brush pens, watercolors, and paintbrushes. As an elementary school teacher by day, Grace combines her love of teaching with her passion for hand-lettering with this very book to model for her students and others that it is never too late to learn something new or make time for what makes you happy.